LORD LEIGHTON

RUSSELL ASH

PAVILION

LORD LEIGHTON
1830—96

Frederic Leighton was born on 31 December 1830 at Scarborough, Yorkshire, the second child of Frederic Septimus Leighton (1799–1892) and Augusta Susan Nash. His grandfather, Sir James Boniface Leighton (1769–1843), was court physician to two Tsars of Russia, Alexander I and Nicholas I, and while in their service amassed a substantial fortune. After attending school in England, Leighton's father studied medicine in St Petersburg. He was an exceptionally talented man, a polymath who had learned Russian in six months and was well versed in the classics and science. Frederic's two sisters were Alexandra (named after and the godchild of the Tsarina Alexandra of Russia), who was to become the biographer of Robert Browning, and Augusta, or 'Gussy'. Two other children, James and Fanny, died in infancy. Frederic Septimus grew increasingly deaf and was compelled to retire from medical practice, but after the death of Sir James, his inheritance meant that the family had sufficient wealth to live wherever they wished, without the need of his gainful employment. This was fortunate since Leighton's mother suffered from ill health, and the family travelled extensively abroad in search of good climates and cures. Thus the young Frederic grew up as a member of a household that was permanently on the move.

Frederic learned Latin and Greek from his father, and after moving via Bath to London attended University College School. In 1839 the Leightons visited Paris, then travelled on to Germany and Italy where they settled – for a typically brief period – in Rome. There Frederic Leighton was exposed to diverse cultural and artistic influences which he was able to absorb with great facility, not least because he was blessed with the ability to learn foreign languages: he spoke French, German and Italian with equal fluency, and later learned Spanish, as well as certain more obscure tongues such as Romanian and the less familiar dialects of some languages. At an early age he showed talent as a draughtsman which, according to some accounts, he first took up seriously while confined to bed with scarlet fever. His father, hoping that his only son would add another generation to the family's medical tradition, taught him anatomy – which he was to turn to his advantage in figure drawing.

In 1842 – after lying about his age – Frederic enrolled in the Berlin Academy of Art, and the following year attended an art school in Frankfurt. In 1845 the Leighton family moved to Florence, where Frederic joined the Academia delle Belle Arti under the teachers Guiseppe Bezzuoli and Benedetto Servolini. He was also taught by the Italian drawing master Francesco Meli and by the distinguished expatriate American sculptor Hiram Powers, who was so impressed with Frederic's ability that he not only encouraged him but, importantly, also encouraged Leighton's father to sanction his artistic training. Powers

reportedly answered Leighton's father's enquiry about whether he should permit his son to become an artist with the comment, 'Sir, you cannot help yourself; Nature has made him one already.'

When Frederic was 16, the family made Frankfurt its base, buying No. 23 Bockenheimerlandstrasse. Its location offered proximity to spas such as Wiesbaden which were popular among visitors from all over Europe (it was the town that Leighton's friend and soul-mate Sir Lawrence Alma-Tadema was to visit for his health and where, ironically, he died). In Frankfurt Frederic studied at the Städelsches Kunstinstitut where his work developed considerably. An official report noted that he 'made excellent progress and moved into his own atelier [studio] and completed a picture which was spoken of as having great painterly talent'. Fellow students painted scenes from popular German legends, influencing Leighton's own interest in mythological subjects. During political disturbances in 1848 the Leightons temporarily left Frankfurt and moved to Brussels where Frederic worked under the tutelage of the somewhat macabre painter Antoine Wiertz; there too he studied the work of Belgian masters including the history painter Louis Gallait, from whom he gained the notion of impressing through vast scale, a technique he was to emulate.

Leighton was in Paris in 1849 where he studied under Alexandre Dupuis, a history painter of mediocre reputation. While in Paris Leighton took the opportunity to visit the Louvre and, as was traditional at that time, make copies of masterpieces there. The next year, the upheavals in Frankfurt at an end, he returned to the city and worked under the newly-appointed Professor Jacob Edward von Steinle, a history painter belonging to the Nazarene School, a group sharing many of the aspirations and some stylistic characteristics of the English Pre-Raphaelites. Leighton also worked in the open air with a group of landscape painters known as the Cronberg School. Fellow student Otto Donner von Richter later recalled the impression Leighton had made on him:

He stands before me: a picture of a youthful, handsome man, full of zest for life, vigour, industriousness, health, and with an outstanding artistic talent.

The early 1850s found Leighton painting scenes from the lives of Italian Renaissance painters including, in 1852, his first major history painting, *The Death of Brunelleschi*. This was a competent but rather immature composition reminiscent of an altar piece, with Renaissance prototypes in scenes of the Virgin's or of saints' deaths, and featured both Leighton's sister Augusta and their father, who posed for the head of Donatello. At this time Leighton developed an interest in the historical aspects of Roman Catholicism

LORD LEIGHTON

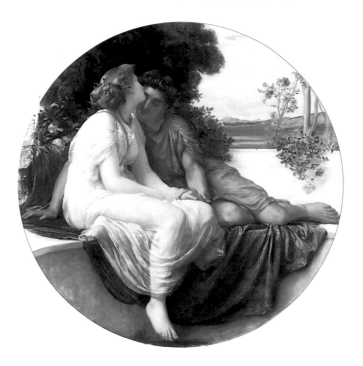

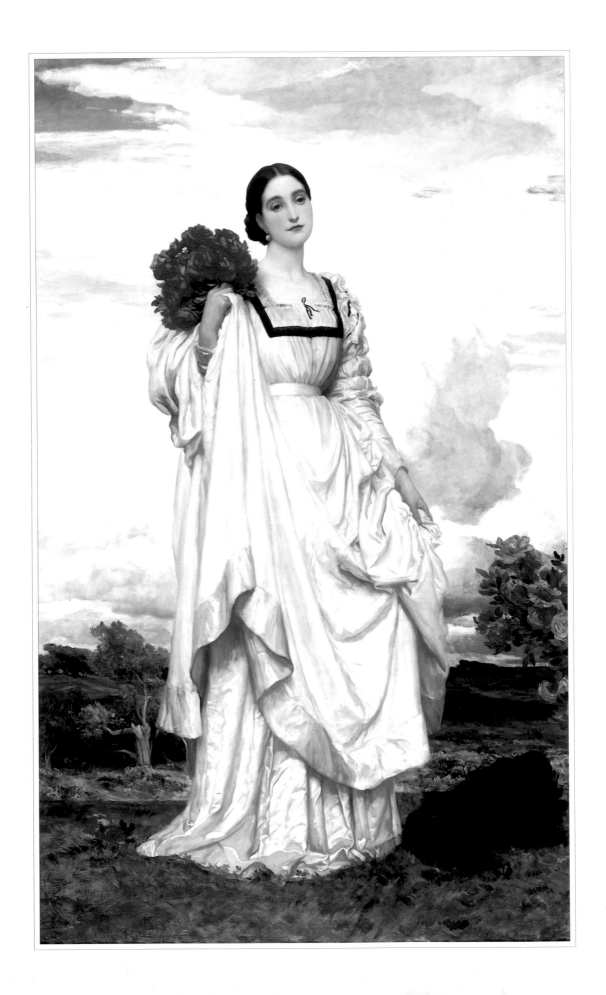

and, like Rossetti and the Pre-Raphaelites in this period, in medieval themes.

He also painted a few portraits in Frankfurt, including those of other émigré Britons and members of the local aristocracy, circles in which he moved with equal ease. He was a popular guest at social gatherings and was noted for his musical talents; he studied singing and piano, and was later acquainted with notable musicians, including Rossini.

In 1851 Leighton returned to London where he visited family members, painting the portrait of his maternal great-uncle Edward I'Anson, and making contact with several English artists who found him an agreeable outsider. He also visited the Great Exhibition, the vast show of arts and sciences centred on the Crystal Palace which attracted some six million visitors.

After 20 years of unsettled but culturally stimulating travel, the Leighton family finally established a home in Bath, but Frederic decided to return to Italy. As he journeyed there he wrote, 'I have opened the introductory chapter of the second volume of my life, a volume on the title-page of which is written "Artist".' He was fully aware that Italy was to provide an enormous stimulus to his artistic imagination, and as he neared his destination he noted: 'Italy rises before my mind. Sunny Italy! I am about again to tread the soil of that beloved country, the day-dream of long years is to become a reality.'

He made architectural studies of medieval buildings in Verona, Venice and Florence before moving on to Rome, arriving there on 19 November 1852. Almost immediately, he experienced a sense of disappointment with the artistic atmosphere, and during his first months in Rome suffered

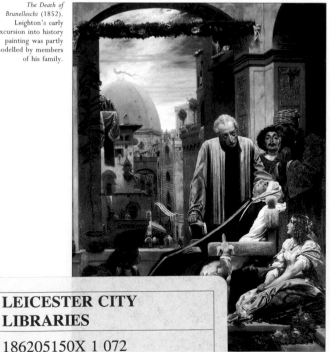

The Death of Brunelleschi (1852). Leighton's early excursion into history painting was partly modelled by members of his family.

from bouts of depression. Equally alarming, his eyesight deteriorated, perhaps a psychosomatic symptom, but one that was unrelieved by the homeopathic remedies he tried. His spirit improved with the coming of spring, though his eyesight problem continued to concern him.

In Rome, Leighton met such expatriates as the British sculptor John Gibson and formed a lifelong and firm friendship with Adelaide Sartoris. The wife of Edward Sartoris and a member of the Kemble theatrical family (her sister was the celebrated actress Fanny Kemble) she was herself an opera singer. Leighton met her early in 1853 and through her *salon* he was introduced to other members of Rome society, most especially, in 1854, Robert and Elizabeth Barrett Browning who remained close friends for many years. Leighton's relationship with Mrs Sartoris has been considered by some prurient observers as scandalous, but it seems highly unlikely that it ever went beyond that of an admiring young artist and a middle-aged woman who was delighted with his company.

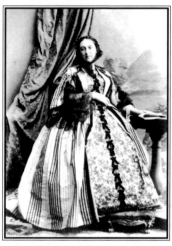

Leighton's influential mentor Adelaide Sartoris (1860), by French society photographer Camille Silvy.

Leighton was clearly attractive to women: all who met him considered him handsome, with a distinctive aquiline nose and a bearing that was dignified and far removed from the casual Bohemianism of many contemporary painters. Leighton himself was to remain unmarried in an age that, at least publicly, placed great store in the institution of marriage and the family. 'I would not insult a girl I did not love by asking her to tie her existence to mine, and I have not yet found one that I felt the slightest wish to marry: it is no doubt ludicrous to place this ideal so high, but it is not my fault – theoretically I should like to be married very well,' he wrote in a letter to his mother.

At this time he spent a good deal of time in the company of Isabel Laing, the daughter of friends of his family, whose portrait he painted and whom he escorted around Rome; however, she later married Joseph Nias, a sailor and Arctic explorer. Suggestions that Leighton was latently or actually homosexual or, since he apparently painted beautiful women and handsome men with equal enthusiasm, bisexual, do not stand up to scrutiny. He was, however, emotionally insecure, and in the many records of his life there exists virtually no evidence of any emotional attachments at any stage. He was at his most relaxed with children, but with adults with whom he came into conflict, he barely kept his volatile temper under control, the Prince of Wales once commenting in a letter '...you know how touchy he is'. His outward self-confidence hid a nervous temperament, and he was prone to self-induced imaginary disorders.

To his apparent remoteness, reinforced by his somewhat austere habits – he never smoke or drank, conducted his business affairs efficiently, and was never in debt – was

added the charge of some that Leighton was self-seeking and snobbish, the artist and novelist George Du Maurier considering that he would not make himself 'agreeable to anything under a duchess'. However, there is ample evidence that he was widely popular, a good friend to many, thoughtful and charitable. When he had himself become famous and successful, he gave both financial support and practical assistance to struggling young artists, even those whose work was aesthetically opposed to his own, among them Aubrey Beardsley.

Leighton's circle of friends in Rome included the architects William Burges, Alfred Waterhouse and George Aitchison, the last of whom was later to design Leighton's famous London house. He also met the landscape painters George Heming Mason and Giovanni Costa, who were to remain friends (and often financial dependants) for the rest of his life. And he numbered among his acquaintances such diverse characters as Jean Jacques Ampère, the son of the man after whom the unit of electrical current is named and an historian of Rome, and the novelist William Makepeace Thackeray, the author of *Barry Lyndon* and *The Virginians*. Clive Newcome in Thackeray's *The Newcomes* (1853–55) was in all probability based on the young Leighton. He is described in the novel as '…the young swell of the artists of that year, and adored by the whole of the jolly company. His sketches were pronounced on all hands to be admirable; it was agreed that if he chose he might do anything.' On returning to London Thackeray prophetically joked with the Pre-Raphaelite painter John Everett Millais that Leighton might well challenge him one day for the Presidency of the Royal Academy.

As his confidence returned, Leighton began work on two major paintings, *Cimabue's Madonna* and *The Reconciliation of the Montagues and Capulets over the Dead Bodies of Romeo and Juliet*. At his second studio in Rome, to which he moved in 1853, George Aitchison read aloud the *Autobiography and Journals* of Benjamin Haydon. Haydon had aspired to be a classical painter, but when his works were shown at the

same venue as the celebrated dwarf known as Tom Thumb and 120,000 visited the latter and only 133 Haydon's exhibition, he shot himself in despair. What might have been a salutary lesson to Leighton in the folly of pursuing an artistic career actually made him all the more determined to do so – but to do so more successfully than any of his predecessors.

In the same year Leighton visited Germany to obtain treatment for his eyesight, visiting his parents in Frankfurt before returning to Rome by way of Venice. He resumed work on his two paintings, taking a break during the summer in Bagni di Lucca. Months of work had gone into his painting of *Cimabue's Madonna*. It had become one of the sights of Rome among fashionable visitors, one of whom criticized its static rigid composition, whereupon Leighton completely revised it. This painting and *The Reconciliation* were finally completed to his satisfaction and he packed them off to London in a crate, feeling 'a kind of strange sorrow at seeing them nailed up in their narrow boxes; it was so painfully like shrouding and stowing away a corpse.'

His intention was to have one or both paintings accepted by the Royal Academy for exhibition in its summer show. In fact, only *Cimabue's Madonna* was accepted. The painting's full title was *Cimabue's Celebrated Madonna is Carried in Procession through the Streets of Florence; in front of the Madonna, and crowned with laurels, walks Cimabue himself, with his pupil Giotto; behind it Arnolfo Di Lapo, Gaddo Gaddi, Andrea Tafi, Niccola Pisano, Buffalmacco, and Simone Memmi; in the corner Dante*. Not only was its title excessively long, but it was also a huge painting, measuring more than seven feet high and 17 feet long. 'One thing is certain,' Leighton pointed out, 'they can't hang it out of sight – it's too large for that.' Just as Cimabue's painting of the Madonna is carried in triumph in the painting and the artist showered with praise for his consummate skill, so Leighton himself, it must be acknowledged, sought the same adulation. And, indeed, he was to receive it when the painting was accepted by the Royal Academy (despite reservations about its size), exhibited and, the crowning glory, immediately purchased by Queen Victoria for 600 guineas (£630). There can be few comparable instances in artistic history: the bestselling first novel, or in modern times the box-office smash of a director's or an actor's début film are the closest parallels, but it was without precedent for an almost unknown young artist to unveil such a monumental and remarkable work as his first publicly exhibited painting – and, what is more, to so captivate the reigning monarch that on the first day of the exhibition it was purchased for the Royal Collection. The work also received critical acclaim, the *Art Journal* observing:

There has been no production of modern times more entirely excellent than this. It is of the truest order of

worth: no 'slap-dash' for effect, no 'niggling' labour in vain; it is faithful to a high purpose: the conception is worthy of the theme, and that theme is of the loftiest, for it elevates and honours and perpetuates the glory of the artist and the Art.

The influential critic John Ruskin began his annual *Academy Notes* that year, describing *Cimabue's Madonna* as 'a very important and very beautiful picture'. Dante Gabriel Rossetti was also conscious of the influence Leighton's work might have in the battle between the Royal Academy and the Pre-Raphaelites, remarking in a letter to William Allingham, 'The RAs have been gasping for years for someone to back against Hunt and Millais and here they have him.'

When news of his triumph reached him in Rome, Leighton immediately used some of his payment to buy works from fellow, less successful artists. He was aware, though, of the pressure such instant fame imposed upon him, in an untypically candid letter telling his mentor Steinle that his success, which 'for a beginner, has been extraordinarily great, fills me with anxiety and apprehension; I am always thinking, "What can you exhibit next year that will fulfil the expectations of the public?"'

Leighton left Rome, telling Steinle, 'My stay in Italy will always remain a charming memory to me; a beautiful, irrecoverable time; the young, careless, independent time! I have also made some friends here who will always be dear to me.' He travelled to London, meeting such influential figures as Ruskin, Rossetti and George Frederick Watts but, continuing his nomadic existence, journeyed on to Paris where he took a studio in the rue Pigalle and exhibited his second major picture, *The Reconciliation*, at the Exposition Universelle. In Paris he met the French artists Jean Ingres and Jean Léon Gérôme; the latter's painting *The Cock Fight* (1847) is seen as pivotal in the new movement towards academic classicism. Leighton again met George Frederic Watts, who was to become a friend, neighbour and ally, and who was similarly influential in Leighton's progressive move towards classical subjects, noted by Robert Browning as 'a sudden taste that has possessed him'. He also associated with the English painter Edward Poynter, whose work shares a stylistic affinity and Leighton is known to have admired such artists as Jean-Baptiste Corot and Jean François Millet, regarded as precursors of Impressionism. As a result of meeting certain artists, including Henri Robert-Fleury, at this point in his career, Leighton adopted the brighter palette that is evident in works from this period onward.

As Leighton had feared, *Cimabue's Madonna* was a hard act to follow. *The Triumph of Music*, shown at the Royal Academy in 1856, received a savage response ('one of the worst pictures of the Exhibition', declared the *Athenaeum*),

and he was criticized too for the anachronism of Orpheus shown playing a violin rather than a classical lyre.

In London in 1856 Leighton used Watts's studio and met the Pre-Raphaelite William Holman Hunt. His contact and friendship with members of the Pre-Raphaelite Brotherhood was especially remarkable since he was broadly opposed to their artistic ideals. But he remained on amicable terms with most of them, in particular Millais, while F. G. Stephens, one of the founders of the Movement who had become art critic of the influential journal the *Athenaeum*, became a vigorous supporter of Leighton's work.

After his failure at the Academy, Leighton did not exhibit in 1857, but worked on a literary painting, *Count Paris, accompanied by Friar Laurence and a band of musicians, comes to the house of the Capulets to claim his bride: he finds Juliet stretched apparently lifeless on her bed*, as well as *The Fisherman and the Syren – from a Ballad by Goethe*, both of which were exhibited at the Royal Academy in 1858, to a lukewarm reception. In *The Fisherman and the Syren*, later retitled *The Mermaid*, Leighton explores the *femme fatale* theme that became popular in later nineteenth-century art, especially in the work of the Symbolists.

Continuing his travels, Leighton spent the winter of 1857–58 in Algiers, where he became fascinated by the colour, architecture and costumes he encountered. Many of these were later used as motifs in his paintings, and even became decorative features in his own house. Leighton then spent his last winter in Rome where he executed paintings of Italian models, including several of the model Nanna Risi ('La Nanna'). One painting of her, *Pavonia*, had already been sold but was reluctantly copied when the young Prince of Wales, then on a tour of Italy in the company of the sculptor John Gibson, asked to purchase it. This marked the beginning of a friendship between the Prince and Leighton that was to last almost forty years.

Leighton returned to London, taking a studio in Orme Square in Bayswater. This he made his permanent base — or as permanent as any of his homes were. Chroniclers of Leighton's life have been perplexed by the almost frenetic pace with which he conducted it. More than any of his contemporaries, he took full advantage of the newly-opened European railway networks and burgeoning steamship business. For years observers noted his seemingly tireless energy as he apparently worked on half a dozen canvases simultaneously while forever dashing off to Italy, Greece, Germany, Ireland, North Africa or the Holy Land in search of new motifs and inspiration. While on these trips abroad he produced oil sketches that he would later use as backgrounds to his studio paintings, as well as fine landscapes such as his 1859 *Garden of an Inn, Capri*.

Portrait of Leighton (1881), one of several by his friend G. F. Watts.

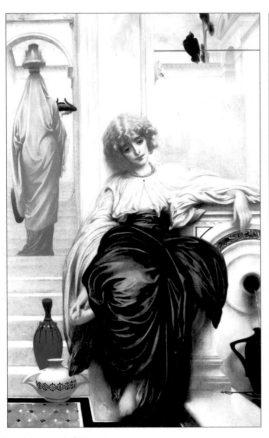

Lieder Ohne Worte (c.1860–61). Leighton's exercise in depicting a musical theme on canvas was originally titled *The Listener*.

providing drawings, for example, for George Eliot's *Romola* (1863). A warm rapport developed between Eliot and Leighton, with Leighton advising her on historical points in her work. In *A Week in a French Country House* (1867), a novel by Adelaide Sartoris, he not only contributed two illustrations, but also features in the novel as the character Mr Kioski, just as Thackeray had used him as a the model for Clive Newcombe. Lightly disguised portraits of Leighton can also be discerned in Gaston Phoebus in *Lothair* (1870), a novel by the Prime Minister Benjamin Disraeli, and, less flatteringly, as Lord Mellifont in Henry James's *The Private Life* (1892).

When war with France was threatened, Leighton joined a volunteer brigade known as the Artists' Rifles Corps to which fellow artists such as Hunt and Rossetti belonged; he designed the Corps' cap with Millais. Leighton rose to a high rank and demonstrated natural qualities of leadership that were to stand him in good stead with his later official appointments.

On the death in 1861 of Elizabeth Barrett Browning, Robert Browning asked Leighton to design her classically-inspired tomb at the Protestant Cemetery in Florence, a poignant commission that reinforced their friendship that had been established in Rome. Decorative work of this kind was mirrored in the decorative subjects that began to emerge in paintings such as *Lieder Ohne Worte* ('Songs without Words') and other works of the period. In a letter to William Allingham dated 10 May 1861, Dante Gabriel Rossetti complained that *Lieder Ohne Worte* was unfairly ill-placed at the Royal Academy, despite being the largest and most important of six canvases Leighton showed that year. Originally intended to be entitled *The Listener*, a friend of Leighton's suggested the new title for the painting, deriving it from Mendelssohn's collection of piano compositions of the same name. *Sisters*, *Eucharis — A Girl with a Basket of Fruit*, which was praised by Ruskin, and *Girl Feeding Peacocks* date from this period, of which William Michael Rossetti wrote:

These belong to that class of art in which Leighton shines — the art of luxurious exquisiteness, beauty for beauty's sake, colour, light, form, and choice details for their own sakes, or for beauty's.

The subject of *Girl Feeding Peacocks* was chosen for its aesthetic value. The sensuous textures of a variety of materials were painted with meticulous accuracy and great technical ability. The girl's dress combines pink silk, red velvet and green-blue sleeves which pick up tones in the peacocks' feathers. To some extent Leighton's exclusion of narrative, as well as his concentration on harmonies of colour and form to affect the viewer, anticipate the Aesthetic Movement.

In 1862 Leighton began one of his few religious compositions, a fresco depicting *The Wise and Foolish Virgins* at the neo-Gothic church at Lyndhurst, Hampshire. Other biblical subjects are found in his work of the 1860s, before his characteristic classical style emerged. These include contributions, along with Hunt and other artists, to the *Dalziel*

During the 1860s, as Leighton sought to consolidate his reputation in England, he became increasingly successful financially. By the early 1860s, when the average labourer's annual income in the United Kingdom was less than £30, Leighton was earning around £4,000 a year, or more than 130 times as much. Besides, he built up substantial holdings of stocks and shares (when he received 1,000 guineas for his *Dante in Exile*, he reputedly invested it in railway shares). Dividends from his investments meant that he did not need to earn anything more professionally. Late in his life he was making around £20,000 a year, with paintings frequently selling for more than £1,000, and notable prices paid for certain important works – £3,937 10s. for *The Daphnephoria*, and *Captive Andromache* fetching a personal lifetime record of £6,000. He became established as a 'gentleman painter', a frequent visitor to many country houses and the recipient of portrait commissions from the many society figures whom he numbered among his friends. Though lucrative, Leighton eventually felt that portraiture distracted him from his true artistic intentions. Rejecting a commission, he once wrote: 'What little leisure I have for portraits (which I own to painting unwillingly) is already given away and I have had to refuse even old friends.'

He persisted with medieval subjects, among them *Paolo and Francesca*, and also began to work as an illustrator,

Bible, and subjects derived from biblical themes, such as *Salomé Dancing*, which he began in 1857 but did not complete until 1863. Despite being described by George Du Maurier as one of Leighton's best paintings, it was rejected by the Royal Academy. As a result Leighton began to fear that certain hanging committee members were secretly opposed to him.

The years since the phenomenal success of *Cimabue's Madonna* were kind but not over-generous to Leighton. The victory he had achieved at the age of 25 had not been repeated, but his reputation was steadily enhanced. Gradually his works had become popular and he was recognized for his qualities not only as an artist but also as a man. It was only a matter of time before this was publicly acknowledged through his elevation to the Royal Academy, which came in 1864 when he was elected as an Associate. Leighton's organizational skills and attributes – not least his widely noted obsession with efficiency and punctuality – immediately came to the fore, as he became increasingly active on committees and in promulgating the educational aspects of the Academy's work.

Now that he was confirmed as an establishment figure, Leighton felt the need to proclaim his status by commissioning his friend George Aitchison (later President of Royal Society of British Architects) to design a house for him. Most of the leading artists of the day built magnificent homes for themselves: Alma-Tadema, a painter whose subject matter and technical virtuosity bear comparison with Leighton's, converted Tissot's modest St John's Wood town house into a sumptuous palace with a vast domed studio. Artists' houses were often featured in the periodical press of the day, the public awed by the near-regal splendour of some of these domiciles. Leighton chose a site in Holland Park Road, London, near Little Holland House, the residence of G. F. Watts. He approached the

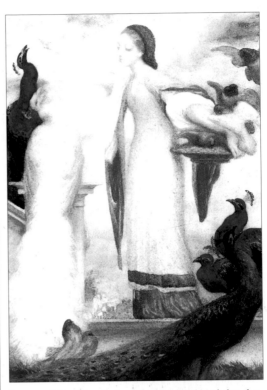

Study for *A Girl Feeding Peacocks* (*c*.1863). The subject was later developed into a rich classical composition.

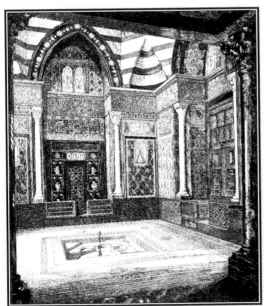

The exotic tiled Arab Hall at Leighton House, the repository of treasures from the artist's extensive travels.

design and financing of the entire operation with his characteristic thoroughness, personally supervising all stages of building and decoration in a highly businesslike manner. He furnished the house with the many treasures he had accumulated on his travels, as well as paintings purchased from contemporary artists. Leighton House – today open to the public and displaying works associated with the artist – also became a stage on which the famous men and women of the age performed, as Leighton, ever the genial host, regularly organized lavish soirées and musical evenings. James Tissot's 1872 caricature of Leighton for *Vanity Fair* aptly depicts him at such an event, languid and elegant in evening dress. A story, possibly apocryphal, recalls that when the artist and renowned wit James McNeil Whistler heard a woman praising Leighton's multifarious accomplishments, his linguistic, social and musical skills, he remarked, 'Yes – paints a little too, I believe.'

Leighton's most typical works – those of his classical period – commenced in earnest with *Orpheus and Eurydice*, his first important classical picture of the 1860s. Among other notable works of the 1860s may be numbered *Dante in Exile*, *The Painter's Honeymoon* and *Mother and Child,* the latter work refuting the occasional assertion that Leighton was incapable of portraying sentimental scenes. *The Syracusan Bride* was both a critical and a commercial success, sold to the London dealers Agnew's for £1,200 in 1866 and eight years later to the shipping magnate Frank Leyland for £2,677 10s.

In 1867 Leighton travelled to Asia Minor and Greece, producing several paintings of coastal scenes that he used

as backgrounds for later works such as *Daedalus and Icarus*. In the legend of Icarus Leighton saw in the potent sun the profound power of spiritual inspiration, writing: 'Sunlight can never be an accessory – its glory is paramount where it appears everything except water is tributary to its song of splendour.' This painting shows Leighton's new-found passion for depicting landscapes bathed in sunlight, in this case based on sketches made in Rhodes in 1867. We see the town, at the head of one of the bays formed by the coastline, below from a dramatic height appropriate to the subject. The painting was acclaimed by the *Art Journal* and likened to a Greek cameo.

Venus Disrobing for the Bath, a large nude subject, shocked some despite its classical allusions. This was Leighton's first major classical nude, and one in which he challenged prevailing notions of propriety and the mistrust of the treatment of the female nude by neoclassical artists. The painting was a deliberate and salacious affront to Victorian conservatism. The vulnerable, unaware frontal nude is watched by the intrusive voyeuristic spectator. F. G. Stephens defended the controversial painting in the *Athenaeum* and the *Art Journal*, declaring that:

A figure like this, which braves prevailing prejudices, not to say principles, can only be justified by success. That Mr Leighton's *Venus* holds its ground that the bold attempt has been treated with respect, amount to a tacit admission that the artist has at any rate not failed. His picture is eminently chaste.

The work was bought by Leighton's close friend, Mrs Eustace Smith, who claimed to have modelled for Venus' feet, as hers, unlike those of the woman who posed for the figure, were so 'unspoilt'.

From this period on, nudes, mythological subjects and other motifs in classical settings dominated Leighton's work. He undertook research and compiled a summary of ideas for such themes that were to serve him for the rest of his creative life. Meanwhile, his wanderlust was unabated, and 1868 saw him in Egypt, travelling up the Nile and visiting Aswan, keeping a detailed diary of his impressions. In the same year he was elected a full member of the Royal Academy, and produced paintings that included *Jonathan's Token to David* and *Actaea, the Nymph of the Shore*.

In 1869 he went to the spa of Vichy in France, accompanying Mrs Sartoris who had been advised to go there for her health. There he met two notable Englishmen, the poet Algernon Swinburne, who was later to commemorate the meeting in his poem 'An Evening at Vichy', and the explorer Richard Burton, whose portrait Leighton was to paint a few years later. In December Leighton's own health was poor, and he suffered from rheumatism that was to trouble him in later life; ironically, he began work on *Hercules Wrestling with Death*.

Leighton's paintings of the early 1870s include *Greek Girls Picking up Pebbles by the Sea*, which contains echoes of the work of the contemporary artists Whistler and Albert Moore, who painted similar aesthetic exercises in classical drapery with no reference to a specific legend. His *The Daphnephoria* represents his finest decorative work from this phase of his career.

Leighton visited Damascus during the autumn of 1873, producing paintings including *Old Damascus: Jews' Quarter*, and assimilating Oriental influences that were to appear in his *Study* and *Music Lesson*. He also purchased artefacts that were later used in the decorative scheme for Leighton House, in particular Arab tiles, as a result of which Aitchison designed for him an Arab Hall in which to display his finds. This exotic room, with its fountain, became the focal point of the house – even though visitors occasionally fell into it. Vernon Lee, a visitor to Leighton House in 1883, described the Arab Hall as 'quite the 8th wonder of the world'.

Mrs Sartoris (whose son Algernon married Ellen, the daughter of US President Ulysses Simpson Grant, in 1874) continued to feature prominently in Leighton's life, and he travelled to Italy with her on more than one occasion in the 1870s. Richard Burton, whom he had met on their Vichy trip, sat for his portrait in 1875. Many critics have regarded it as Leighton's finest portrait, and the most revealing of the subject's powerful personality. It had a great impact when shown at the 1878 Exposition Universelle in Paris, where it was acclaimed by the Impressionist supporter Louis Duranty. As a gesture in return, in 1876 Burton secured an important consignment of tiles for Leighton's house, taken from the tomb of Sakhar on the Indus.

Sculpture was a subject that fascinated Leighton. His wide circle of friends always included many sculptors – he was one of first British collectors of work by French sculptor Auguste Rodin – and he himself often made clay models as an aid in planning a painted composition. He produced only two full-sized works, *Athlete Wrestling with a Python*, inspired by the Laocoön that he had seen in Rome, and *The Sluggard*, both bronzes owned by the Tate Gallery and on loan to Leighton House.

Venus Disrobing for the Bath (1866-67) was considered one of the more risqué of Leighton's many nudes.

Works from the late 1870s include *Study: at a Reading Desk*, *Music Lesson* and *Winding the Skein*, the first two with nominally Oriental and the third with classical references, but all three genre pieces showing everyday life. Such works were popular with Victorian audiences: just as Alma-Tadema has been described as the painter of 'Victorians in togas', so Leighton must have been aware of the sentimental frisson that Victorians felt when they observed their own familiar daily activities translated to ancient settings, emphasizing the affinity of their own culture with that of an Imperial predecessor. Other works by Leighton in the same vogue include paintings with sentimental titles such as *Farewell!* in which a lover's departure is witnessed. Such titles and their subjects, often showing the middle classes in repose, were interchangeable with those of Alma-Tadema.

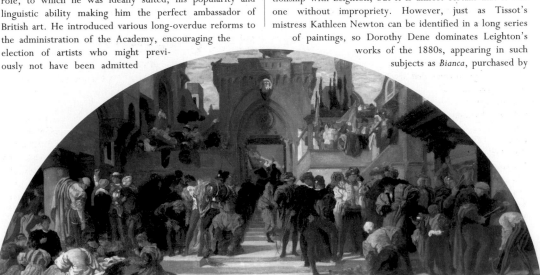

At the end of the 1870s Leighton worked on long-planned frescoes in the South Kensington (Victoria and Albert) Museum, *The Arts of Industry Applied to War and Peace*. These were not his only fresco commissions – his *Phoenicians Bartering with Ancient Britons* at London's Royal Exchange, executed in 1894–95, is, unusually (and not very successfully), a fresco executed on canvas which was then mounted on the wall.

Just as Thackeray had teased Millais, hearing him speak at a dinner in London when Leighton was just 21, the painter Frederick

Psamathe (c 1880), an unusual and haunting image of the sister of Actaea, whom Leighton had previously depicted in Actaea, the Nymph of the Shore.

Goodall had prophesied to a fellow guest that Leighton would one day become President of the Royal Academy. Goodall's prediction came true in 1878 when, on the death of Sir Francis Grant, who had been President since 1866, and with wide popular support – not least from his friend the Prince of Wales – Leighton was elected to this important office. Soon afterwards he was knighted at Windsor Castle.

Leighton applied his superb organizing skills to his new role, to which he was ideally suited, his popularity and linguistic ability making him the perfect ambassador of British art. He introduced various long-overdue reforms to the administration of the Academy, encouraging the election of artists who might previously not have been admitted

as Academicians, and urging the nation to purchase important works of art. He was also active on the boards of national museums including the British Museum and National Portrait Gallery and used his considerable influence to enable Sir Henry Tate to establish the Tate Gallery. He was ahead of his time too in promoting environmental causes such as restricting the erection of buildings on open public spaces, in smoke abatement and the conservation of ancient buildings.

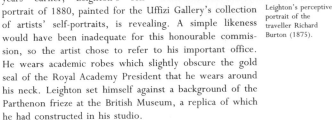

Leighton's perceptive portrait of the traveller Richard Burton (1875).

Like Burton's portrait of five years earlier, Leighton's self-portrait of 1880, painted for the Uffizi Gallery's collection of artists' self-portraits, is revealing. A simple likeness would have been inadequate for this honourable commission, so the artist chose to refer to his important office. He wears academic robes which slightly obscure the gold seal of the Royal Academy President that he wears around his neck. Leighton set himself against a background of the Parthenon frieze at the British Museum, a replica of which he had constructed in his studio.

The year after his election, Adelaide Sartoris, Leighton's closest friend, died, and he experienced a deep sense of loss. A consolation of sorts arrived in the person of Dorothy Dene, who became his model and muse during his final years. Dorothy Dene (1859–99) was the professional pseudonym of Ada Alice Pullan, a girl from a large family that she was attempting to support through modelling; her sisters also occasionally sat for Leighton. Dorothy could have been the prototype for Eliza Doolittle to Leighton's Professor Higgins in G. B. Shaw's *Pygmalion* (and, indeed, Shaw knew them both), so much did the besotted Leighton attempt to educate her and mould her career. He aided her in her ambition to become an actress, and she had a brief but unspectacular stage career. Rumours inevitably circulated about the nature of her relationship with Leighton, but it is almost certain that it was one without impropriety. However, just as Tissot's mistress Kathleen Newton can be identified in a long series of paintings, so Dorothy Dene dominates Leighton's works of the 1880s, appearing in such subjects as *Bianca*, purchased by

The Arts of Industry Applied to War (1878–80), one of a pair of large frescoes executed for the Victoria and Albert Museum.

encapsulate the artistic currents of the age. In 1885 he was instrumental in ensuring that Burne-Jones received the honour of being elected as an Associate of the Royal Academy, even though he was to resign five years later. Leighton himself received innumerable honours that ranged from honorary doctorates of many universities to European knighthoods and membership of leading art academies.

By the late 1880s he was suffering increasingly from ill-health – angina was diagnosed – but he kept up his relentless European travels and demanding work schedule. Friends died: he was a pall-bearer at Browning's funeral in 1889, and his father died at a great age in 1892. The following year he undertook a hectic tour of Germany, and in 1894 was suffering from exhaustion, despite which, in 1895, he travelled to North Africa and Italy. In the 1896 New Year Honours List he was created Baron Leighton of Stretton but, uniquely, was a peer for a single day. The Letters Patent confirming his Baronetage were signed on 24 January, and he died the next day at his home in London with his sisters and friends beside him. Without heirs, his peerage became void upon his death. On 3 February he was buried in St Paul's Cathedral. In his last hours he had written a will leaving a sum of money for Dorothy Dene and setting up the Dene Trust, for the benefit of her and her sisters. His last publicly reported words were 'Give my love to all at the Academy'.

the Prince of Wales, and in some of Leighton's best-known and most spectacular late paintings, including *Captive Andromache*, *The Bath of Psyche*, *Flaming June* and *The Garden of the Hesperides*.

Leighton conducted his office as President of the Royal Academy with great diligence. From 1879 to 1893 he delivered biennial addresses in which he attempted to

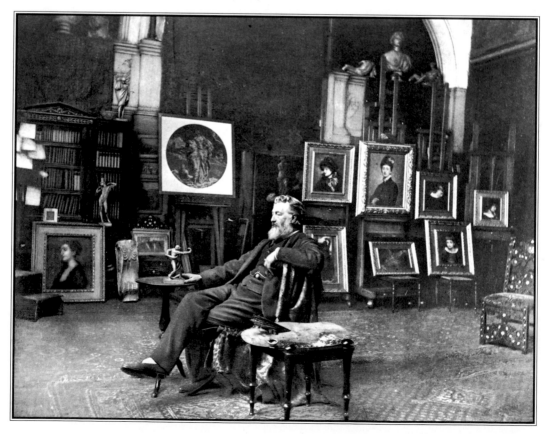

The Plates

PLATE 1

CIMABUE'S CELEBRATED MADONNA
—————————— 1853–55 ——————————
Oil on canvas, 87½ × 205 in / 222.2 × 520.5 cm
HM The Queen

Leighton's second history painting, begun in late 1853, was executed in the artist's studio on the Via San Felice, Rome. His first processional painting, it is a scene of medieval Italian life, for which Leighton made studies of models wearing authentic costumes from the Middle Ages. It is a celebration of Florentine art, and was inspired by Vasari's description of the procession of the Rucellai Madonna to the church of Santa Maria Novella in Florence, the striped marble walls of which can be seen behind the figures. The location can also be identified by the inclusion of another Florentine landmark, the church of San Miniato. Cimabue, the central figure, walks before his masterpiece (now known in fact to be the work of Duccio). Cimabue is accompanied by his pupil Giotto and is observed by Dante on the right. Cimabue and Giotto are separated from the other characters, both physically and it seems psychologically, a feature that is enhanced by the comparatively simple background behind them. Symmetry has been employed here on a large scale, the composition balanced on either side of a vertical dividing line through Cimabue, with the Madonna mirrored by a Gothic niche in the wall. The figures are arranged in balanced flanking groups with a slightly raised figure to the far right and left of the painting. *Cimabue's Madonna* is an exposition of the artist's remarkable talent of composition and his skill in representing linearity and spatial relations, its uniformity broken at intervals only to prevent monotony. The canvas was the culmination of laborious and meticulous preparatory study. As well as seeking advice from several painters in Italy, Leighton corresponded with his former tutor Steinle in Frankfurt about the treatment of this subject, writing in 1854: 'I therefore took a canvas of 17½ feet (English measure), in consequence of which my figures have become half life size...and do not look at all ill.'

On seeing early designs for the composition of the painting, the artist Cornelius advised Leighton to direct the nearest group towards the spectator to prevent a frieze-like effect; however Leighton set the figures too low and failed to create a naturalistic effect of perspective. The painting had an eclectic range of influences, not simply Florentine. Leighton was inspired by the processional paintings of Bellini and Carpaccio that he had seen in Venice, as well as the rich use of colour in Venetian art generally. He was also influenced by early nineteenth-century German painters who had painted the same subject, particularly the large-scale works of Moritz von Schwind. The relationship between the human and architectonic elements in the composition reveals the influence of Raphael and Leonardo da Vinci. The painting is classical in its symmetrical form and balanced areas of colour. It is embellished with Gothic motifs, rather like the contemporary architecture of Barry and Pugin's Palace of Westminster. The painting earned Leighton much attention, Ruskin admiring it for its fulfilment of what he saw as true Pre-Raphaelite principles. The subject-matter is highly appropriate to the success of the work and the artistic prestige it brought to Leighton. Sent to the Royal Academy in early 1855, this large painting was accepted, albeit with concern about its size. It was bought on the opening day of the exhibition by Queen Victoria for 600 guineas (£630), the Queen noting:

There was a very big picture by a young man, called Leighton...it is a beautiful painting quite reminding one of a Paul Veronese, so bright and full of lights. Albert was enchanted with it, so much that he made me buy it.

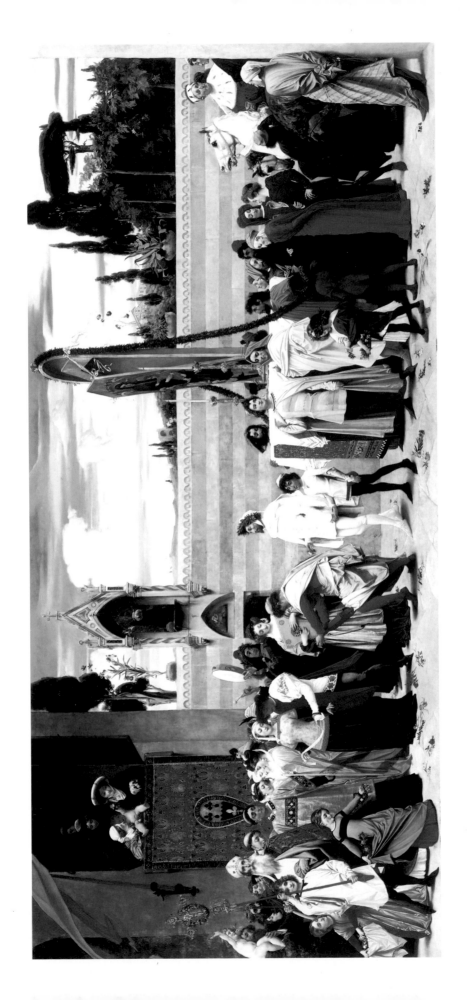

P A V O N I A
———— 1859 ————

Oil on canvas, 21 x 16 ¹/₂ in / 53.3 x 41.9 cm
Private collection

In a letter to his mother, Leighton wrote, 'I am just about to despatch to the Royal Academy some studies from a handsome model, "La Nanna". I have shown them to a good many people, artists and "Philistines", and they seem to be universally admired.' Bearing various titles, this was a series of portraits of the model Nanna Risi, known as 'La Nanna', later the mistress of the German painter Anselm Fuerbach, an artist whose career closely paralleled Leighton's. Various titles were given to paintings in the series, including the model's nickname, *A Roman Lady*, and this subject, *Pavonia*, a reference to the peacock-feather fan that frames her head. The portraits were well received at the Royal Academy, the *Athenaeum* critic commenting:

Mr Leighton, after a temporary eclipse, again struggles to light. His heads of Italian women this year are worthy of a young old master — so rapt, anything more feeling, commanding or coldly beautiful we have not seen for many a day.

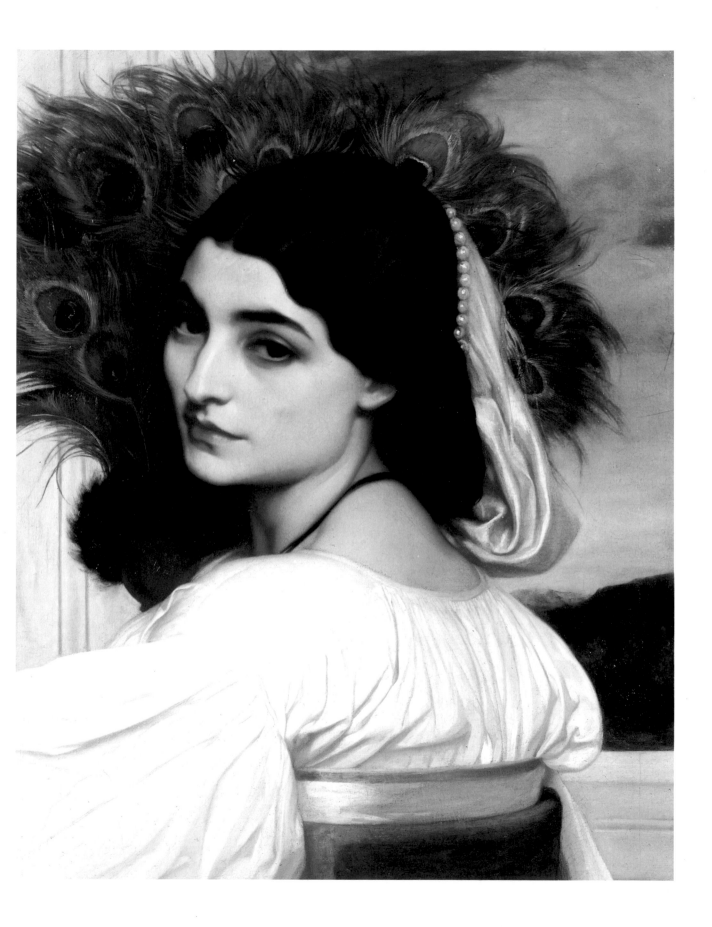

P L A T E 3

GARDEN OF AN INN, CAPRI
———— 1859 ————
Oil on canvas, 19¼ × 26¼ in / 48.9 × 66.7 cm
Birmingham Museums and Art Gallery

A companion piece to *Capri: Sunrise* of the same year, this painting
was executed during a five-week working visit to southern Italy.
Leighton painted as series of small urban studies of Capri to remind
him of the effect of sunlight falling on the clustered houses. The
whitewashed buildings absorb the bright light that is strongly
contrasted by the dark green, lush foliage. Pre-Raphaelite in its level
of detail, the still and claustrophobic atmosphere of the
Mediterranean climate has been effectively captured. Painted for
personal pleasure rather than public criticism, *Garden of an Inn, Capri*
is on a slightly larger scale than the other studies Leighton made of
Capri. It was painted in the garden of an inexpensive hotel, run by
Pagano and frequented by artists seeking cheap accommodation. The
painting was bought for 200 guineas (£240) by Benjamin Godfrey
Windus, a retired coachmaker from Tottenham, London, who
collected works by Turner and was a patron of the Pre-Raphaelites.

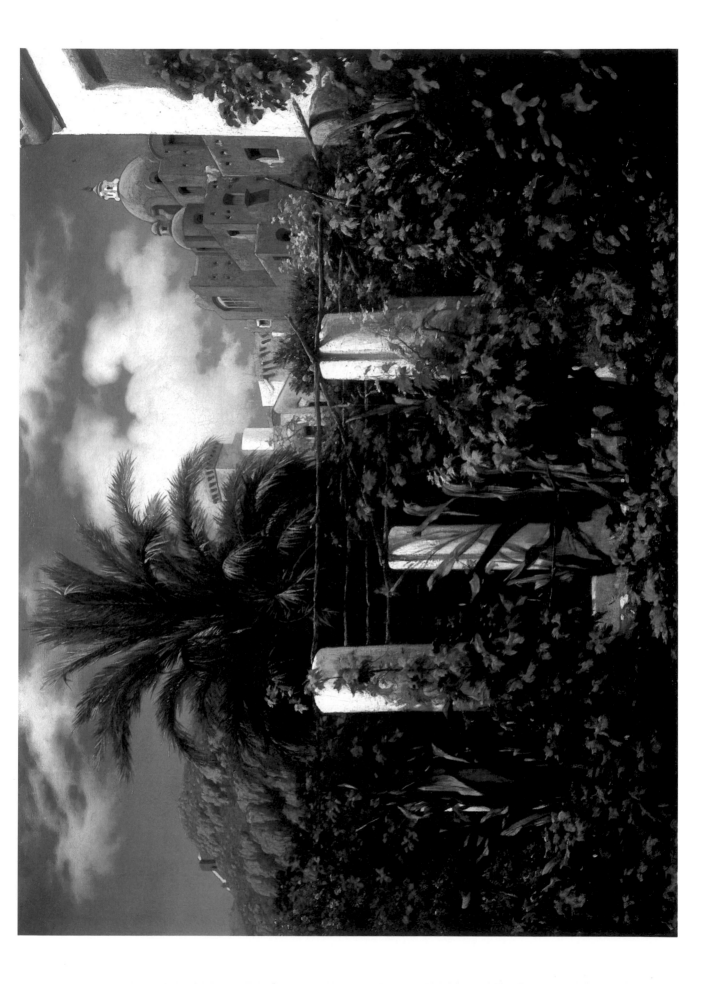

May Sartoris
——————— c.1860 ———————
Oil on canvas, 59⅞ × 35½ in / 152.1 × 90.2 cm
Kimbell Art Museum, Fort Worth, Texas

Leighton was extremely grateful to Adelaide Sartoris, who helped to launch him into society in Rome. After moving around Europe with almost as much frequency as the Leightons, the Sartoris family settled at Westbury House in Hampshire in 1859. Leighton spent a lot of time, including several Christmases, with the Sartorises at their country home, where this portrait of May (Mary Theodosia, born 1845) was executed. The self-assured young woman, then aged 16 though she appears younger, strides towards the spectator through her family's estate. It was something of a rarity for Leighton to paint such an evocative English landscape. He has constructed spatial relations in the composition by means of placing a felled tree across the path to obscure the junction of the foreground and background. May holds up her heavy blue skirt, away from the chalky ground, and her solemn riding attire is brightened by a vibrant red scarf. This painting has a certain vivacity that is lacking in Leighton's other portraits, perhaps because Leighton was especially fond of the attractive young woman. The artist painted a very distinctive portrait of May later in life when she was Mrs Henry Evans Gordon.

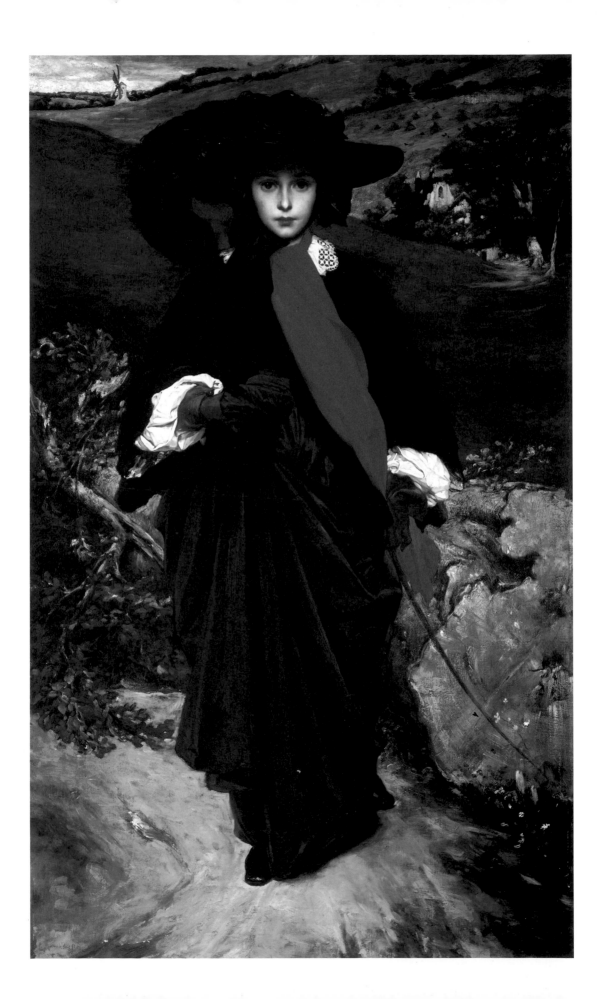

SISTERS

——————— c.1862 ———————

Oil on canvas, 30 × 15 in / 76.2 × 38.1 cm

Private collection

One of six canvases accepted (out of eight submitted) by the Royal
Academy in 1862, the good hanging position of *Sisters* was some
compensation for the rejected and badly hung canvases that Leighton
had previously submitted to the Academy. It is a charming depiction
of two female figures in a lush garden. The young woman bends
down lovingly towards the little girl; their relationship is unclear,
appearing more maternal than sisterly, but was possibly a loving trib-
ute to Leighton's own two sisters Alexandra and Augusta. The
evocation of affection and delight was later captured by Leighton in
Music Lesson. The young woman's dress is a luxuriant masterpiece in
voluminous yellow drapery, cascading from her narrow waist and
contrasting with the lustrous texture of the marble pavement. Sisters
was very well received and according to Leighton was particularly
admired by the Pre-Raphaelite painter John Everett Millais. The
atmosphere of the painting can be likened to that of Arthur Hughes's
simpler single figure composition, *April Love* of 1855. The purchase
of *Sisters* by Stewart Hodgson, a wealthy solicitor whose daughters
were painted by Leighton and who later commissioned *The
Daphnephoria*, gave the artist a needed boost of confidence after a lull
in acclaim since the success of *Cimabue's Madonna*. The painting was
sold at auction in London in 1990 for £480,000.

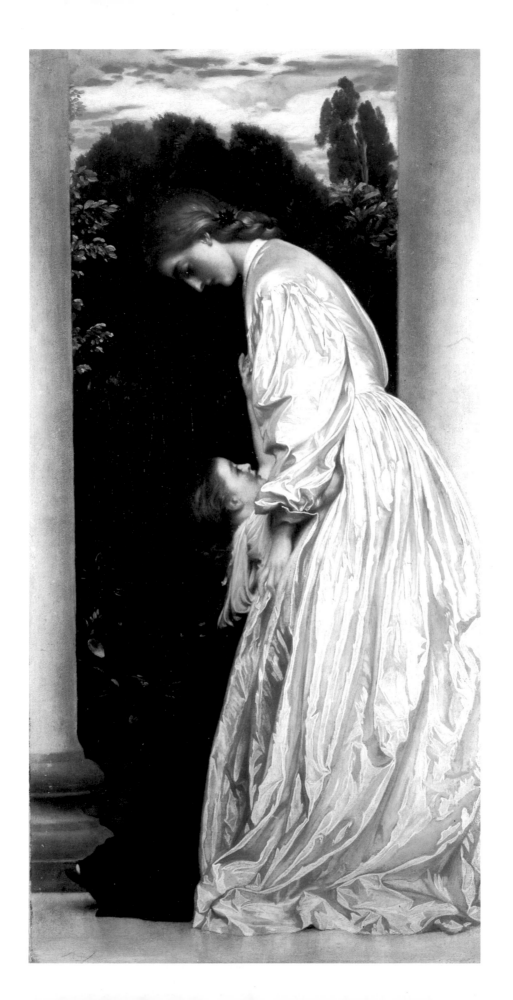

EUCHARIS – A GIRL WITH A BASKET OF FRUIT

———————— c.1863 ————————

Oil on canvas, 33 × 22¾ in / 83.8 × 57.8 cm

Private collection

Exhibited at the Royal Academy in 1863 together with *A Girl Feeding Peacocks*, this painting was first owned by a collector called Albert Levy. The concentration on the girl's neck and the treatment of her upraised arm is reminiscent of Mannerist art. The lighting from the front, which recalls Caravaggio, illuminates the model's back and shoulder rather than her face, and silhouettes the nape of her neck against the sombre background. This flamboyant use of lighting and the painting's dramatic form were considered by some critics as a challenge by the artist to the traditional propriety of representation. The figure has none of the qualities customarily associated with her caryatid pose, the reference to antiquity merely having a decorative function. John Ruskin recognized a source in Venetian art, but criticized the painting for what he considered incorrect perspective in the treatment of the basket.

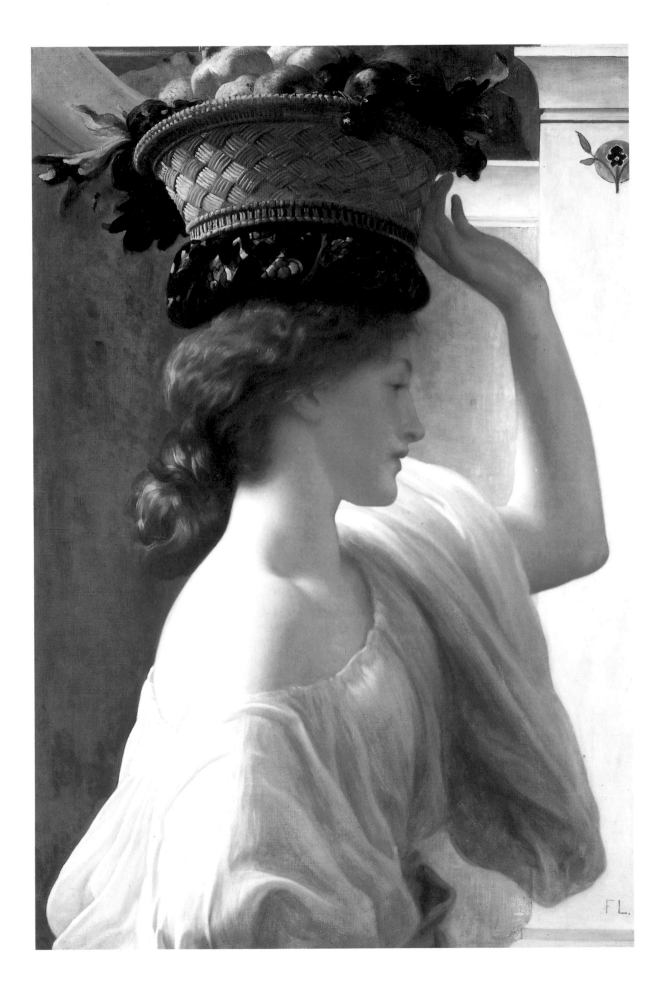

PLATE 7

DANTE IN EXILE

c.1864

Oil on canvas, 60 × 100 in / 152.5 × 254.0 cm
Private collection

Also known as *Dante at Verona*, this large and complex painting was exhibited at the Royal Academy in 1864. It illustrates verses in Dante's *Paradiso*:

> Thou shalt prove
> How salt the savour is of others' bread;
> How hard the passage, to descend and climb
> By others' stairs. But that shall gall thee most
> Will be the worthless and vile company
> With whom thou must be thrown into the straits,
> For all ungrateful, impious all and mad
> Shall turn against thee.

Dante is ridiculed by an antagonistic crowd, having been forced to leave Florence for Verona. Once again, Leighton has used the device of distancing figures from the central character to represent psychological isolation, as previously seen in *Cimabue's Madonna* and later in *Captive Andromache*. The drama is heightened by the aristocratic woman in green, to Dante's left, who gazes upon him with pity and, to his right, the mocking jester, while other groups of activity fade into the background. This painting is considered the culmination of Leighton's early work as well as a precursor to his later decorative works. The success of the painting helped Leighton to establish his reputation at home and was instrumental in securing his election as an Associate of the Royal Academy in the summer of 1864. It was even praised by the *Art Journal*. Previously critical of the lack of concrete subject matter in Leighton's paintings, it stated that '...powers which have previously been scattered, strivings that have hitherto fallen short of the ends at which they have aimed, are in the present exhibition gathered together, and have now in great degree found their fulfilment.' In the year of its exhibition, *Dante in Exile* was purchased for £1,000 by Ernest Gambart, the shrewdest and most successful European art dealer who had bought much of Dante Gabriel Rossetti's work. In 1990 this painting was sold at auction in London for £1,000,000, establishing a new world record price for a work by Leighton.

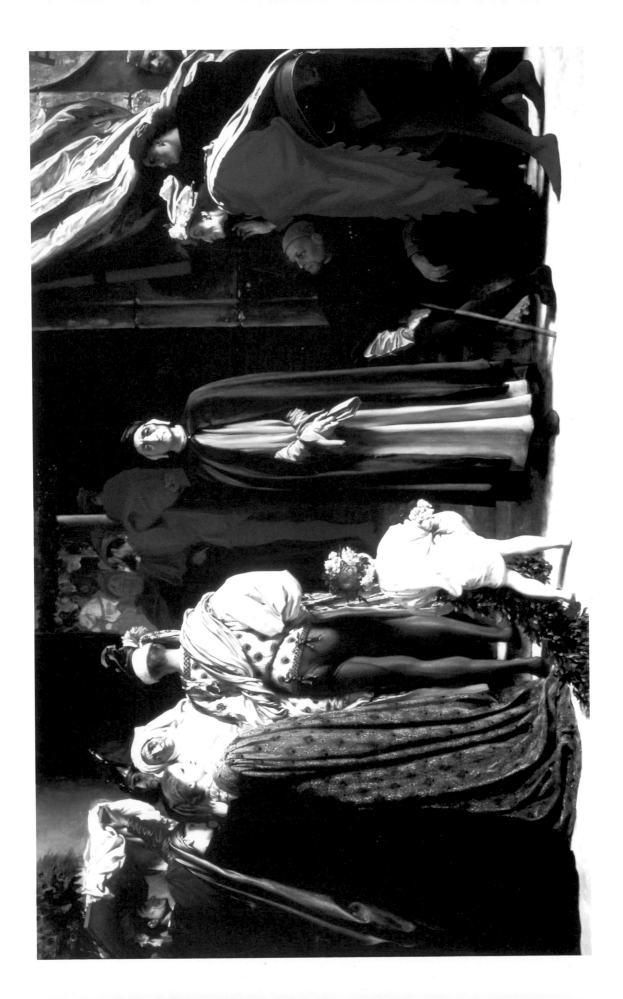

THE PAINTER'S HONEYMOON
———— c.1864 ————

Oil on canvas, 33 × 30 ½ in / 83.8 × 77.5 cm

Charles H. Bayley Picture and Painting Fund, Courtesy Museum of Fine Arts,
Boston

The provenance of this painting cannot be traced from 1870. Bought by a Mr Moreby in 1864, *The Painter's Honeymoon* was not exhibited at the Royal Academy until 1866. The cause of this is unknown but perhaps the painting had too many personal connotations for the introverted and solitary Leighton. In contrast to the viraginous women in his classical paintings, here Leighton has captured the intimacy, affection and serenity of companionship. The mood recalls some Pre-Raphaelite paintings, such as Michael Frederick Halliday's *The Measure for the Wedding Ring* and John Everett Millais' *The Huguenot*. The figures are captivated by their love for each other, and this is emphasized by the lack of accessories or background detail. The same models appeared in Leighton's painting *Golden Hours*, also executed and exhibited in 1864.

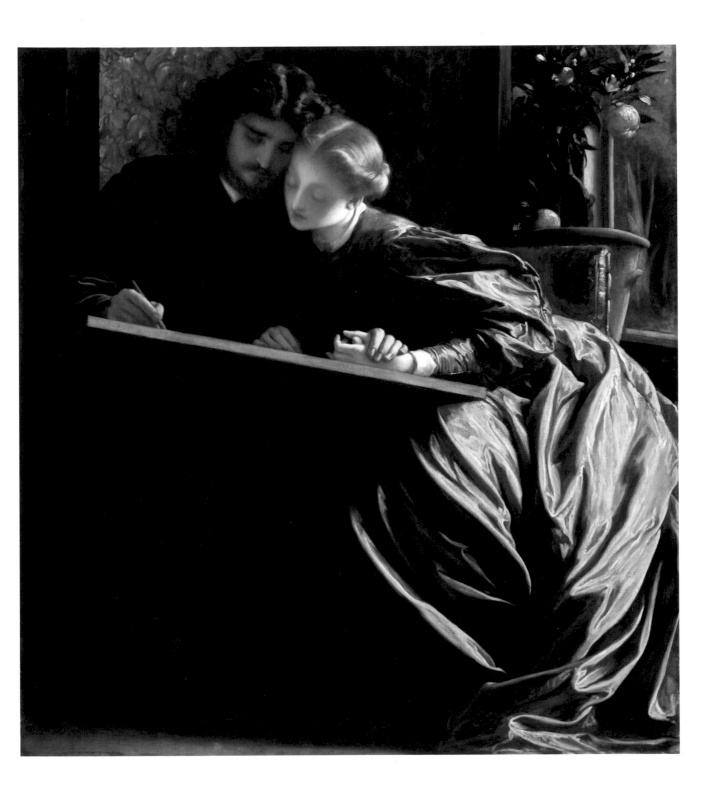

MRS JAMES GUTHRIE

————— c.1864–66 —————

Oil on canvas, 83 × 54¹/₂ in / 210.7 × 138.5 cm
Yale Center for British Art, Connecticut

Exhibited at the Royal Academy in 1866, the early ownership of this painting past that of the sitter cannot be traced. The canvas is richly decorative with meticulous attention to detail and ornament. The chair, inlaid with ebony and mother-of-pearl, is balanced by two contrasting vases of roses and lilies. Leighton's precocious depiction of texture was unrivalled in this period. The sombre background is created by the fading tapestry of a pastoral scene, with the artificial lighting enhancing the sitter's pallid fragility; many sittings were cancelled as a result of her poor health. The painting is reminiscent of Venetian portraits of the sixteenth century, which Leighton had seen on his visit to Venice in the autumn of 1865. The colour scheme is low key and balanced, the model's dress forming a black pyramid broken by minimal ornamental elements and flanked by areas of red from the tablecloth and seat cover. There is little indication of the sitter's personality, Leighton using beauty for its own sake in his portraits of women as well as in idealized narrative compositions.

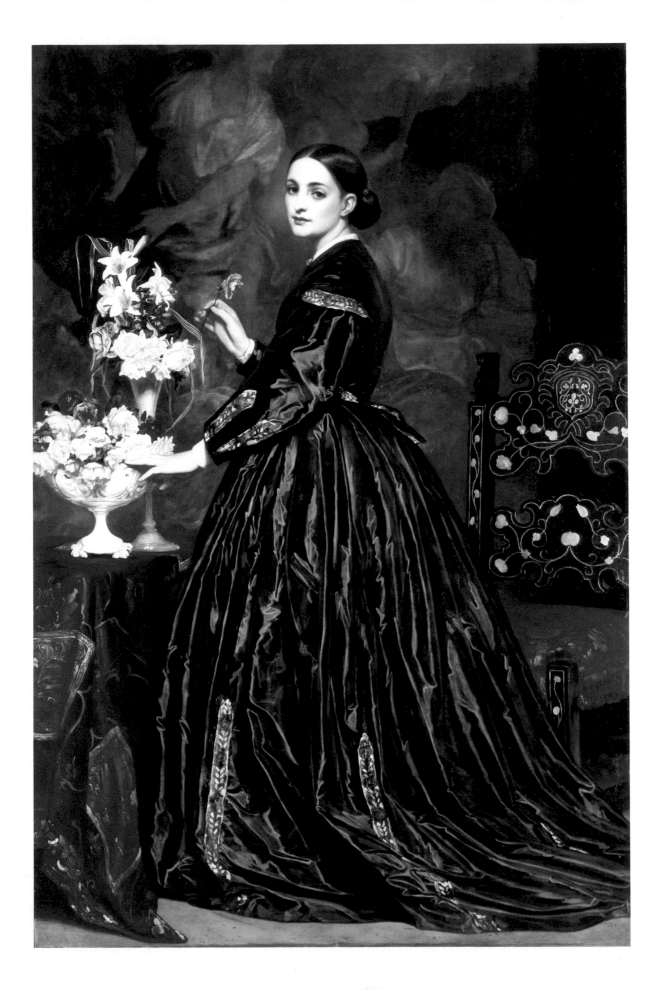

PLATE 10

MOTHER AND CHILD
c.1865

Oil on canvas, 19 × 32¼ in / 48.2 × 82.0 cm
Blackburn Museum and Art Gallery

Mother and Child, one of five paintings exhibited at the Royal Academy in 1865, is a theme steeped in Victorian sentimentality, a celebration of family life in a climate of high infant mortality and questionable morals. F. G. Stephens wrote of the painting:

> Another picture, a very charming one indeed, illustrates what is the most popular side of Mr. Leighton's art... A young mother lies sidelong upon the floor of a room; her head is raised upon her elbow, and, in the hollow of her bent form, nestles a little child, her own, who playfully, daintily, and with exquisite childish grace, presses to her lips a full blooded cherry.

The reclining pose of the woman anticipates Leighton's *Actaea, the Nymph of the Shore*. The artist was concerned about avoiding prettiness when representing sentimental themes: 'By the by, if you think my picture pretty, please don't say so: it's the only form of abuse which I resent.' There is a close focus on the figures, the mother's sleeve and shirt cropped by the edge of the painting and her draped hips at the centre of the composition. The Oriental carpet in the foreground, the gilded decorative screen in the background and the vase of lilies to the left of the composition reveal Leighton's preoccupation and delight in detail and ornament, while the rich colouring once again recalls Venetian art.

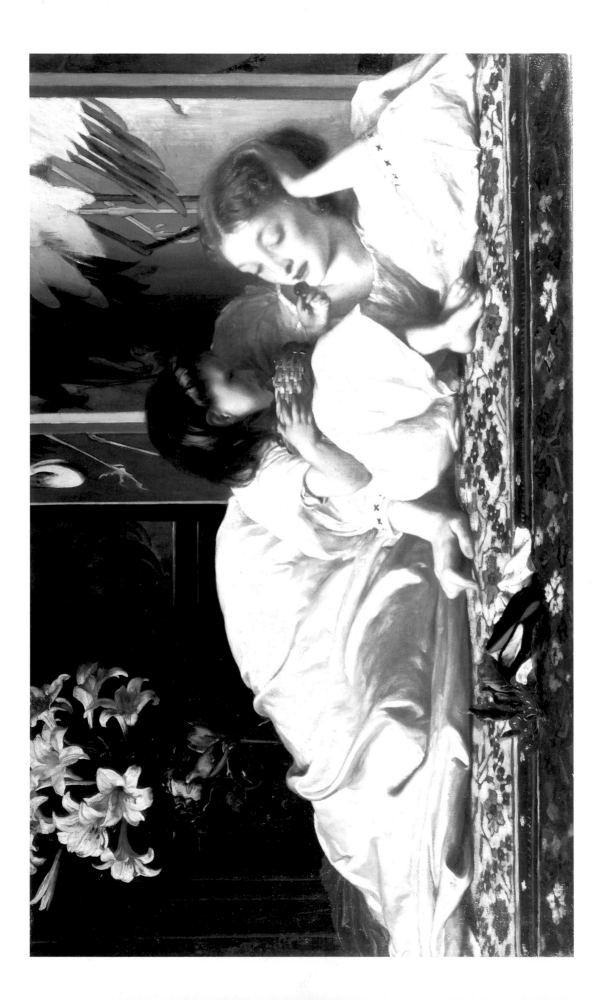

PLATE 11

THE SYRACUSAN BRIDE
———— 1865–66 ————
Oil on canvas, 53 × 167 in / 134.7 × 424.3 cm
Private collection

Leighton was anxious about the reception of *The Syracusan Bride*, the full title of which is *The Syracusan Bride leading Wild Beasts in Procession to the Temple of Diana*. However, the painting became the sensation of the Royal Academy in 1866 and was sold to Agnew's for £1,200. Considered a key work in the development of Leighton's classical style, it is his largest painting since the mannered *Cimabue's Madonna*, executed a decade earlier, and until *The Daphnephoria* of a decade later which marks Leighton's High Renaissance. The processional painting has an unremitting symmetrical composition, the figures moving uniformly across the canvas, broken at intervals by others who have turned. Once again, the painting has no concrete subject, but was suggested by a passage in the second *Idyll* of Theocritus. Leighton linked this scenario to the Syracusan tradition of sending betrothed girls to the temple of Artemis to appease the virgin goddess. Theocritus's description of the procession is somewhat incidental to the main theme of his poem, and thus the link between image and text is rather tenuous. The main source of inspiration was probably the aesthetic potential of a procession of graceful young women, a theme also exploited by contemporary painters such as Alma-Tadema, although here the statuesque brides-to-be are decidedly reserved. As in *Cimabue's Madonna*, the main figure is isolated at the centre of the composition, flanked by symmetrical groups of figures. The rather static left side of the painting is contrasted by the animated contrapposto dynamics of the animals and their attendants on the right. The cropped figures in the foreground enhance the movement in the composition. The white platform, a common compositional device used by Leighton, is echoed by the clouds, framing the shadowed figures of the procession to give a bas-relief effect. The cropped statue is a reference to the antique sculpture *Diane de Versailles* in the Louvre.

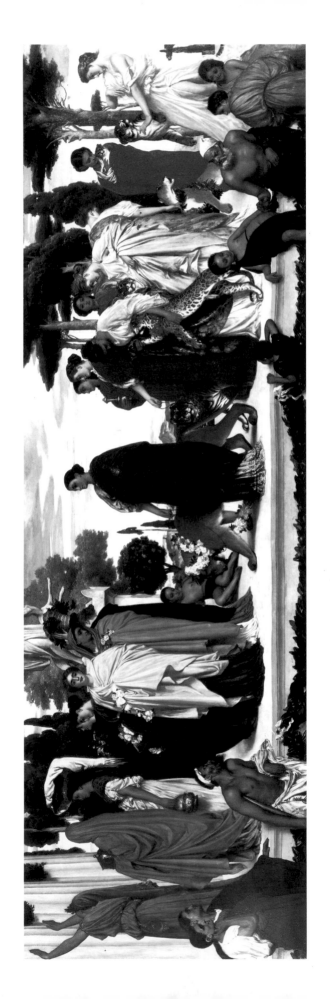

JONATHAN'S TOKEN TO DAVID
———————— c.1868 ————————

Oil on canvas, 67½ x 49 in / 171.5 x 124.5 cm
The Minneapolis Institute of Arts, Van Derlip Fund

The subject of this painting, exhibited in 1868, was taken from chapter 20 of the *First Book of Samuel*. Jonathan is depicted looking out into the field as he prepares to fire three arrows. He is accompanied by Ezel who waits to retrieve them. David, not seen, is hiding somewhere in the landscape nearby and waits for Jonathan's sign that he is safe to come out of hiding from King Saul. Leighton used this story as an allegory of mutual loyalty, the subject lacking narrative but preempting the conclusion. The treatment of the subject has a certain ruggedness appropriate to the Old Testament. Jonathan's contrapposto pose was perhaps influenced by Michelangelo's *David*, evident in the angle of his shoulders and his statuesque scale. The upraised arm also suggests antique statues of Diana while the relaxed nature of the figure recalls Greek sculptures of Apollo. The picture is thus a fusion of Leighton's meticulous study of the art of antiquity coupled with his well-rehearsed and precise life studies.

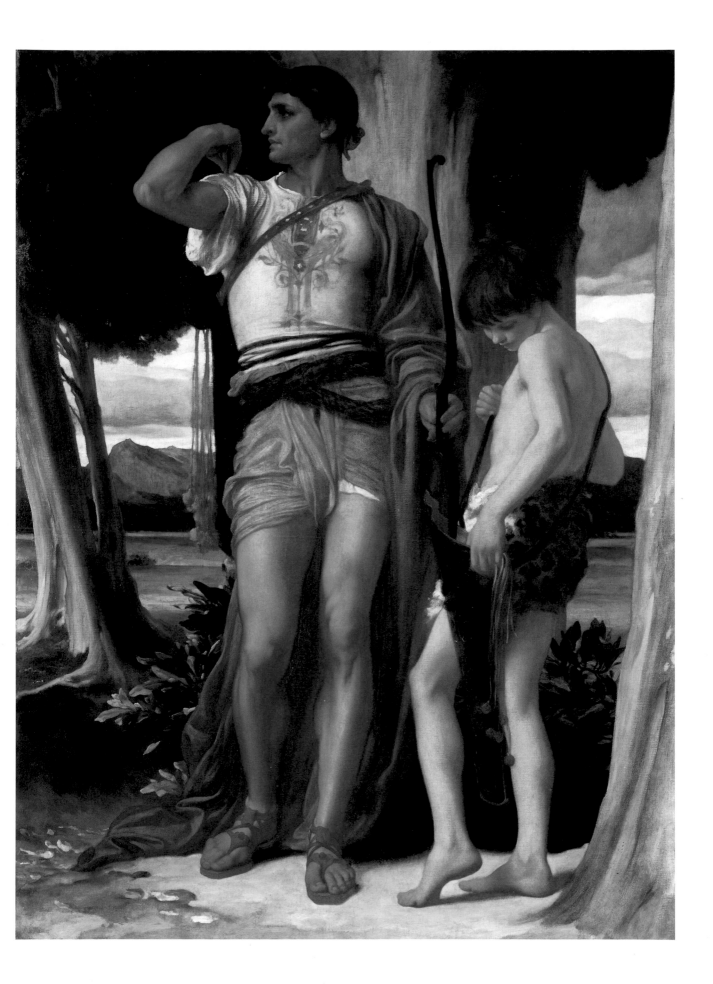

ACTAEA, THE NYMPH OF THE SHORE
—————————— c.1868 ——————————
Oil on canvas, 22 ½ × 40 ¼ in / 57.2 × 102.2 cm
National Gallery of Canada, Ottawa

Exhibited in 1868, this painting was inspired by the ancient works of art and the dramatic landscape Leighton saw on his visit to Greece in 1867. Concluding that the Ancient Greeks had executed classical art in its true spirit and purest form, particularly in the sculpture and architecture of the fifth century BC, Leighton denounced Renaissance art, which had previously been a great source of influence to him, as artificial and less refined. This, Leighton's second attempt at painting a nude, depicts a Nereid, a mythic guardian of the sea. The Nereids were the 50 daughters of Nereus and Doris, the daughter of the ocean. The classically posed reclining figure, a configuration usually associated with Venus, has anatomical discrepancies: Actaea's top half is disproportionate to her lower body, a mistake that occurred in Leighton's previous work *Venus Disrobing for the Bath*, exhibited in 1867. This, coupled with her disdainful expression, gives the figure an awkwardness and a lack of sensuality. Swinburne reviewed the painting critically, feeling that it: '...has the charm that a well-trained draughtsman can give to a naked fair figure; this charm it has, and no other.' The painting's importance lies in its commitment to classicism and knowledge of the art historical canon. Executed at the same time as work by the French Neo-Classical school of painters, such as Alexandre Cabanel, it was probably also influenced by Leighton's recent acquisition of a study by Ingres, *The Odalisque and the Slave*. The timeless seascape behind the nude, taken from sketches made in Rhodes, provides a flat background. The composition is divided by the horizon line, parallel to the broad shoulders of the reclining woman. Leighton praised the effect of this increasingly popular background to the female nude: '...the calm of the ocean is the grandest of all.' The same Rhodian coastline appears later in *Daedalus and Icarus*.

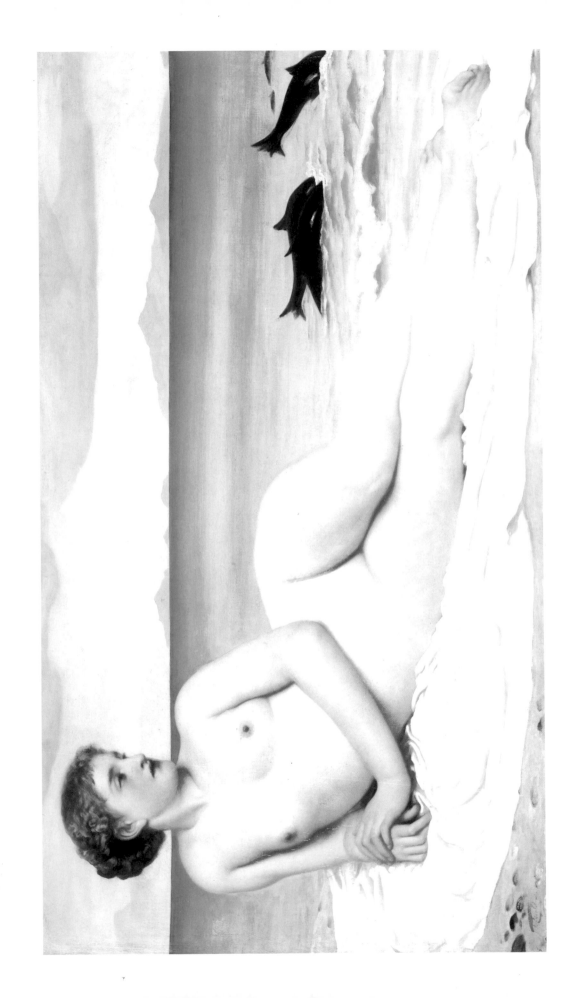

HERCULES WRESTLING WITH DEATH FOR THE BODY OF ALCESTIS

——————— 1869–71 ———————

Oil on canvas, 52 ⅛ × 104 ½ in / 132.4 × 265.4 cm
Wadsworth Atheneum, Hartford: The Ella Gallop Sumner and Mary Catlin
Sumner Collection Fund

Through an intermediary of Apollo, Admetus, King of Pherae, had been assured by the Fates that he would not die if someone consented to die in his place, which his wife Alcestis agreed to do. Just before her burial, Hercules passed by and wrestled with Thanatos (Death), succeeded in rescuing her from Death's clutches and returned her to her husband. These events were described in *Alcestis*, a tragedy by Euripides, and later in poems by both Robert Browning and William Morris. Leighton included the violent vignette, enacted off-stage in Euripides's play, in this, one of his most elaborate and theatrical compositions. The combination of the vigorous action and the mourning figures creates a tense atmosphere, with the flanking groups of activity on each side connected by the recumbent woman. A sombre eclipse shape towards the top of the painting encloses a shimmering visionary seascape at dusk and the illuminated figure of Alcestis, who is draped in white, symbolizing her purity, like Juliet in Leighton's *The Reconciliation of the Montagues and Capulets over the Dead Bodies of Romeo and Juliet*. The movement of the wrestling figures anticipated Leighton's sculpture *Athlete Wrestling with a Python*, executed in the mid-1870s, and is reminiscent of imagery traditionally used for Jacob and the angel. Hercules's pose recalls the *Burghese Warrior*. It was the sight of this painting that inspired Browning to include Leighton in his poem *Balaustion's Adventure*:

> I know too, a great Kaunian painter, strong
> As Hercules, though rosy with a robe
> Of grace that softens down the sinewy strength:
> And he has made a picture of it all.

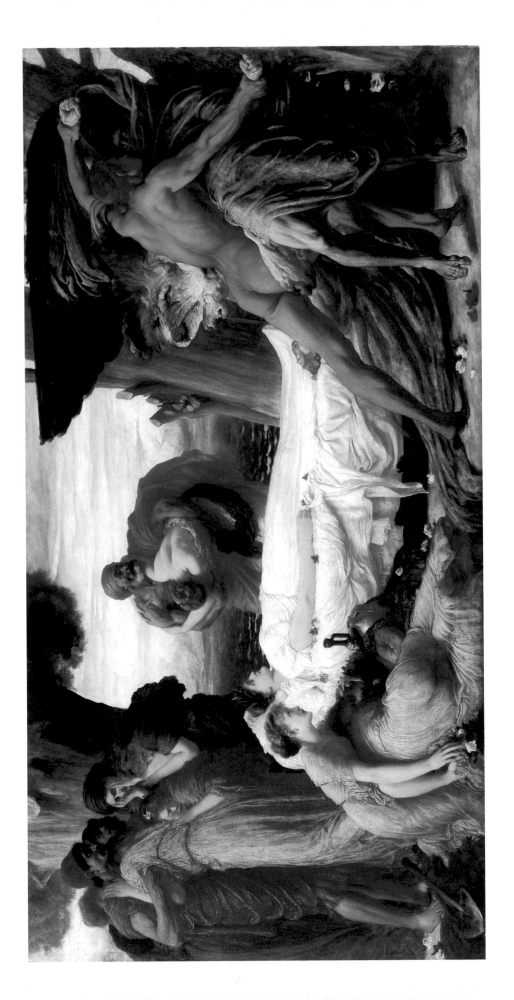

PLATE 15

GREEK GIRLS PICKING UP PEBBLES BY THE SEA
—— c.1871 ——

Oil on canvas, 33 × 51 in / 84.0 × 129.5 cm
Private collection

This canvas is an aesthetic scheme without narrative or didactic purpose. In the timeless seascape setting, the four women, bending or standing, are components of an undulating abstract rhythm of colour and form. The graded warm colours and the folds of the drapery unify these four separate entities. F. G. Stephens, a frequent supporter of Leighton's work, applauded him for his choice of subject and its affinity to the artist's style:

> Never was Mr. Leighton happier in choosing a subject which, in itself, is nothing, but is charming in his hands, than in *Greek Girls Picking up Pebbles by the Sea*: a delightful composition, comprising figures of almost exhaustless grace, and wealth of beauty in design and colour, besides what loveliness it shows in the stooping forms of the damsels, whose draperies a boisterous wind tosses without betraying.

Leighton was additionally commended for representing the female form without impropriety or titillation.

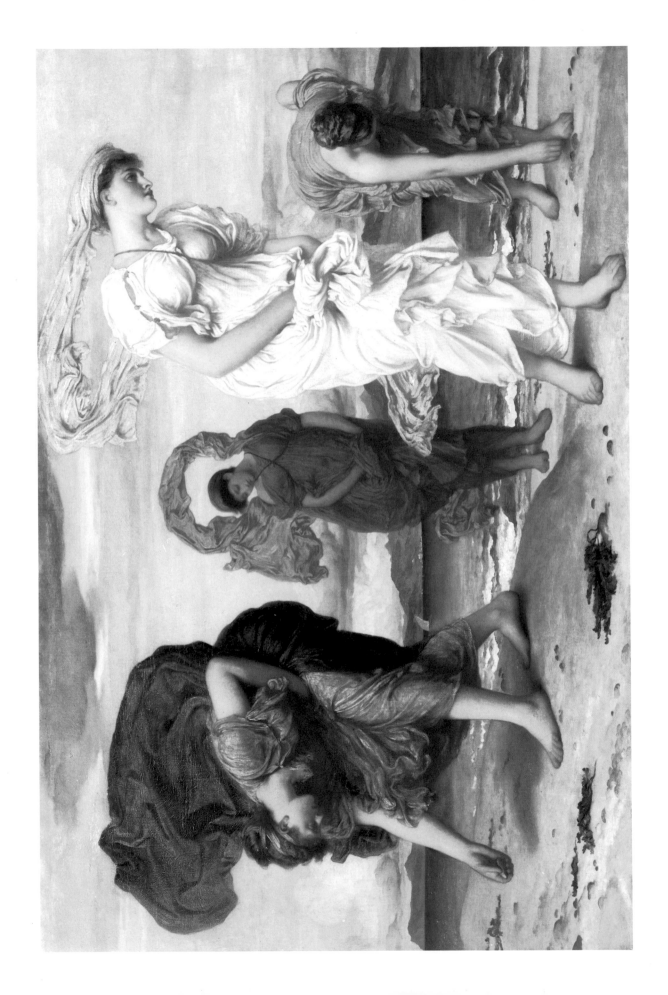

O L D D A M A S C U S : J E W S ' Q U A R T E R

———————— c.1873–74 ————————

Oil on canvas, 53 × 42 ½ in / 134 × 108 cm
Private collection

Leighton travelled to Damascus in autumn 1873, part of his journey spent uncomfortably aboard a Russian ship bound for Beirut. As he headed overland he gained his first glimpse of the city, a sight that impressed him as he noted: 'It is a great and rare thing for an old traveller not to be disappointed, and I am grateful that it has been so with me this time.' He explored the city and sketched some of the more interesting houses, including that owned by Richard Burton, the former British Consul. He developed one of his studies of a courtyard into this painting of girls engaged in picking lemons, which was exhibited at the Royal Academy in 1874. Leighton's fascination with Middle Eastern scenes and his magpie-like habit of collecting objets d'art wherever he visited provided him with the props for such later paintings as *Study: at a Reading Desk* and *Music Lesson*, and the furnishings and decoration for his exotic house in London. The painting made £350,000 when it was sold at auction in London in 1983, setting a new record for the artist; it was re-sold 10 years later, when it fetched £400,000.

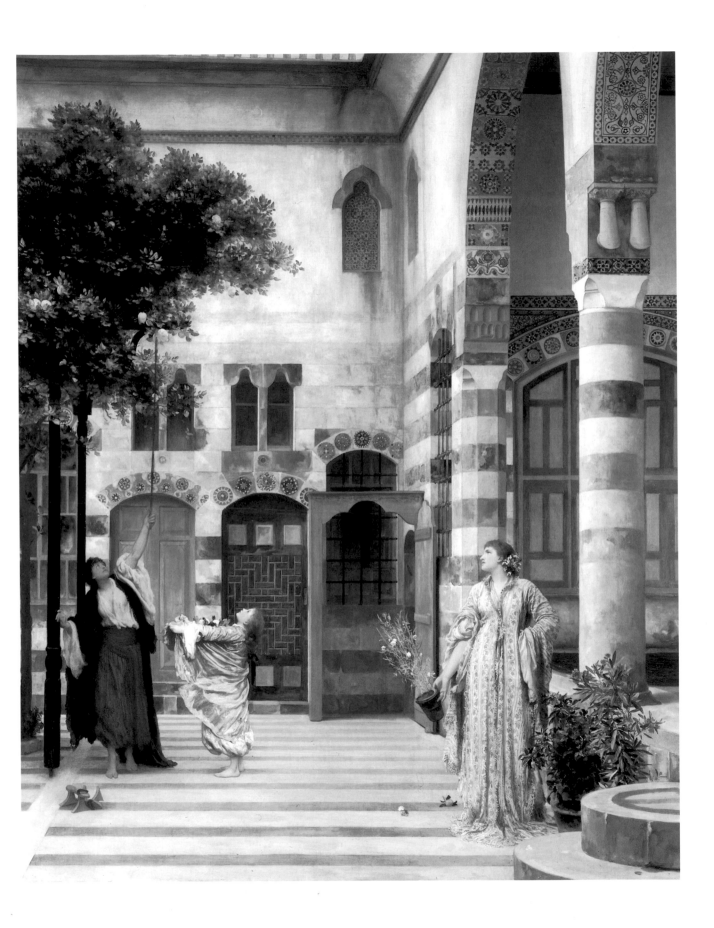

PLATE 17

THE DAPHNEPHORIA
———— c.1874–6 ————

Oil on canvas, 89 × 204 in / 226.0 × 518.0 cm
Board of the Trustees of the National Museums and Galleries on Merseyside
(Lady Lever Art Gallery)

Having taken two years to complete, and exhibited in 1876, *The Daphnephoria* was Leighton's largest and most ambitious painting to date, lavishly described by Holman Hunt as: '...the finest, the most beautiful picture in the world.' Commissioned in 1874 for the Surrey home of Stewart Hodgson, who had bought Leighton's decorative painting *Sisters* in 1862, the painting was purchased for £3,937 10s. in 1893.

Daphne was the daughter of Ladon, the river god. Apollo attempted to seduce, then ravish her, but she was saved by Gaea, who opened up the earth. Daphne disappeared into the ground and a laurel tree sprang up, whereupon Apollo made the plant sacred. Here we witness the people of Thebes, seen in the distant left, in a tribute to Apollo in celebration of their victory over the Aeolians. Held every nine years, the procession was described by Proclus:

> They adorn a staff of olive wood with garlands of laurel and various flowers. On the top of it a brazen globe is placed, from which smaller globes are hung. Purple garlands, less than those on the top, are attached to the middle of the staff, and the lowest part is covered with a saffron-coloured veil.

The priest, known as the Daphnephoro or laurel-bearer, in the white and gold toga and the multi-pointed diadem and carrying a laurel branch, leads the procession to Apollo's temple. Before him is a distinguished-looking semi-nude youth who holds a standard symbolizing the sun, moon and stars. At the rear of the procession, five boys carry symbols of Apollo in the form of golden tripods. The figures in the procession are entranced by the power of Apollo. The male figure with the pronounced musculature and his back to the spectator is Choragos, representing Polykleitos's perfect man, the typical Olympian strong man. The iconography in *The Daphnephoria* is not historically or archaeologically correct, but it embodies the classical ideals of harmony, completeness and beauty and contains many references to classical sculpture. This painting combines aesthetics and music in the vibrant drapery and rhythmic movement of the chorus of young women, all of whom were modelled by the young Connie Gilchrist. With *The Daphnephoria*, Leighton moved away from the horizontal format of the procession used in his previous works. The L-shaped pavement, upon which more than thirty figures march, is seen in perspective and the merging groups of figures in an oblique line is more naturalistic. Leighton made preparatory sketches from both nude and draped models as well as making clay models that could be rearranged to work out the interrelation of the characters. The *Art Journal* praised how with the '...precision of drawing and such suavity of modelling, the poet is merged in the painter'.

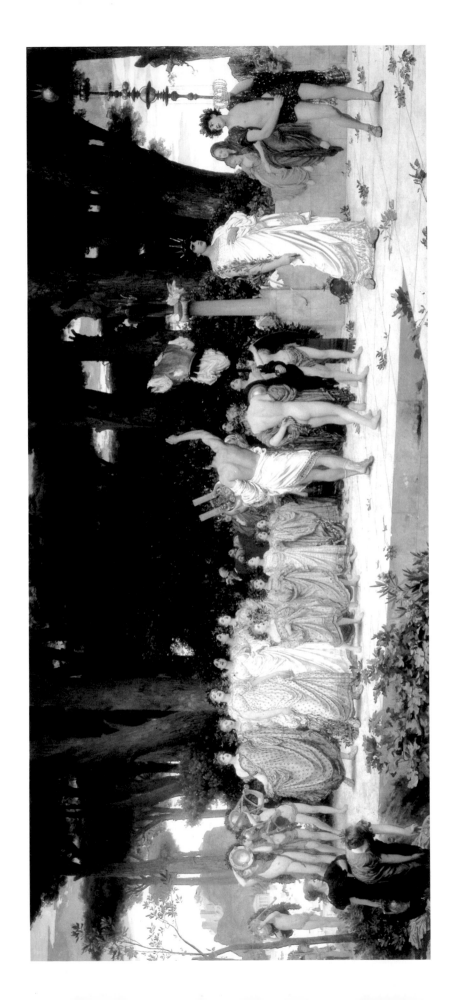

PLATE 18

STUDY: AT A READING DESK
———————— 1877 ————————

Oil on canvas, 24 7/8 × 25 5/8 in / 63.2 × 65.1 cm
Board of the Trustees of the National Museums and Galleries on Merseyside
(Sudley House, Mossley Hill, Liverpool)

This was one of several canvases inspired by Leighton's Middle Eastern travels. Like *Music Lesson*, this painting features Connie Gilchrist who also posed for Lewis Carroll, and modelled for Whistler in *Harmony in Yellow and Gold*. She featured in several of Leighton's works of this period before pursuing a music-hall career as a novelty skipping-rope dancer at the Westminster Aquarium, and later married Lord Orkney. Here she appears in an Arabic setting with costumes the artist had brought back from Damascus. Every surface is lavishly ornamented. Leighton was part of a wider group of artists interested in all aspects of exotic and Eastern art that was particularly fashionable in Europe in the 1870s. The painting was purchased by a Miss Augusta Smith.

PLATE 19

MUSIC LESSON
—————— c.1877 ——————
Oil on canvas, 36$\frac{1}{2}$ x 37$\frac{1}{2}$ in / 92.8 x 118.1 cm
Guildhall Art Gallery, London

Musical themes had proven very successful for Leighton in the 1860s and he returned to them in the 1870s as a result of his growing preference for physically passive scenarios. This intimate variation on the theme, sold in 1891 for £2,400, depicts a woman physically helping a girl, modelled by Connie Gilchrist, to play an instrument while tuning the instrument with her left hand and holding the child's finger on the strings with her right. The figures have intent expressions and delicately modelled hands and feet. The work is similar in atmosphere to *Cleobulous Instructing his Daughter Cleoboline*, exhibited in 1871, but placed in an exotic rather than classical setting. The Arabic costumes and setting were inspired by Leighton's travels in the Middle East earlier in that decade. The models are surrounded by and dressed in souvenirs from Damascus. The painting displays Leighton's talent at depicting textures, from the variegated marble of the bench to the silk clothes. The *Art Journal* praised the painting's 'sensuousness of finish'. In this luxuriant setting the two figures form a central pyramid accentuated by their luxuriant robes. The elaborate architecture in the background has a decorative rather than narrative function. The black and white bands of cold tonality are broken by vivid touches of colour in the drapery and by the flowering pomegranate branch on the floor.

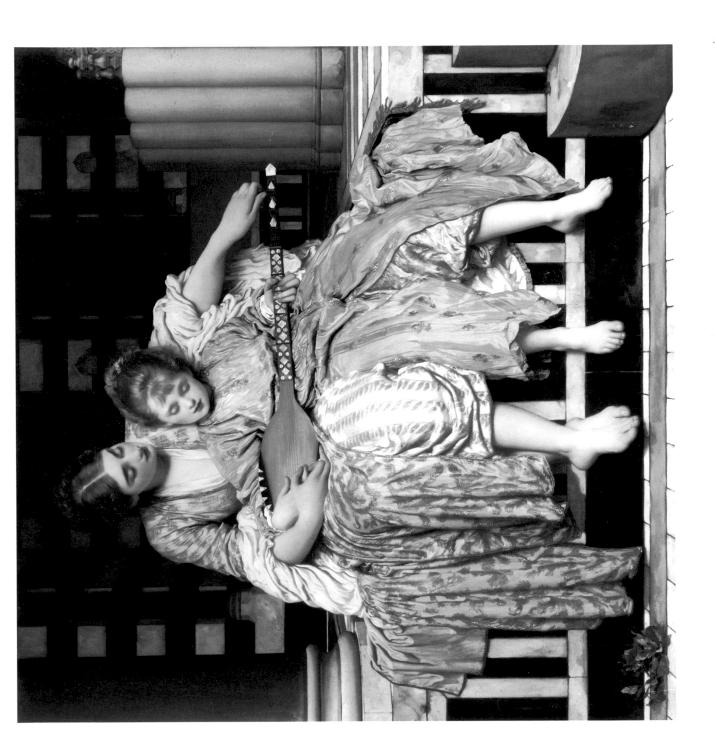

WINDING THE SKEIN
———————— c.1878 ————————
Oil on canvas, 39½ × 63½ in / 100.3 × 161.3 cm
Art Gallery of New South Wales, Sydney

Leighton's deliberate attempt at populism, with picturesque classical nuances, is closely linked to Jean-Louis Hamon's *Skeinwinder*. Hamon was the leader of the French Neo-Greek school who painted simple genre scenes. Such scenes were also popular with the Victorian audience in England, as the *Magazine of Art* explained:

> Mr. Leighton paints trivial subjects for his admirers, and great ones for the love of art. The public accepts him purely as a decorative painter, yet we detect far loftier aims than the ends of decoration in some...works of noble interest which he has given to the world.

In 1884 the Fine Art Society produced an engraving of this painting that was very widely distributed. The two models, seen previously in his *Music Lesson*, are engaged in the familiar task of winding wool. The relaxed postures of the fair, barefooted girls were the result of careful life studies. Leighton was criticized for his highly-finished paint surface which was not only becoming dated, but gave the models' flesh a waxy, lifeless appearance. The very ordered composition is divided into three clear sections: the brief foreground, the flat roof terrace on which the girls sit, and the distant view of blue sea and purple mountains beyond. This was the last of Leighton's paintings modelled by Connie Gilchrist.

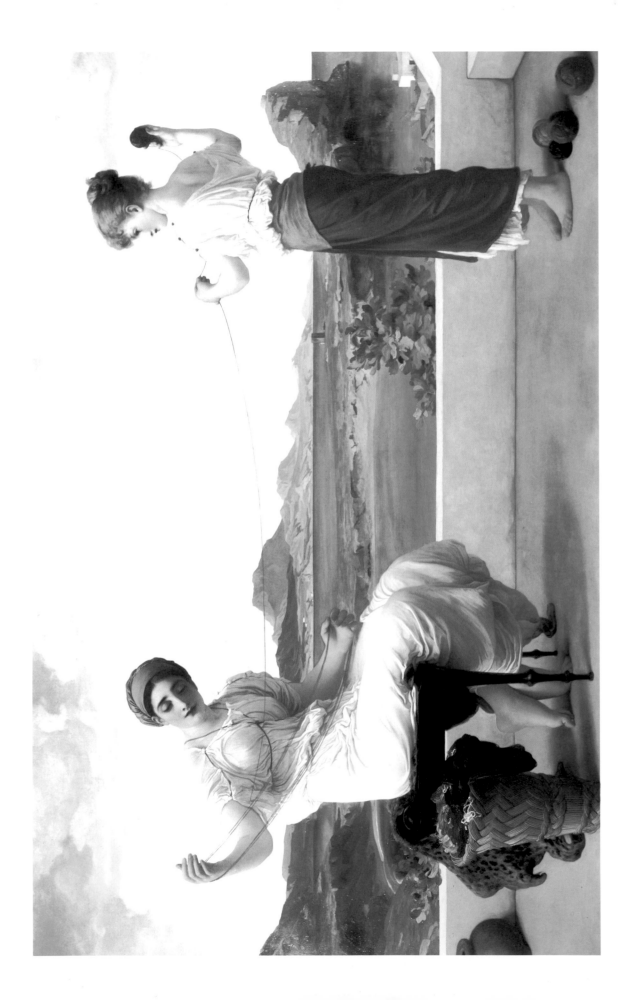

PLATE 21

ELIJAH IN THE WILDERNESS
——————— c.1878 ———————

Oil on canvas, 92 1/2 × 82 7/8 in / 235.0 × 210.0 cm
Board of the Trustees of the National Museums and Galleries on Merseyside
(Walker Art Gallery, Liverpool)

This was one of eight canvases Leighton exhibited at the Royal
Academy in 1879, the first year of his Presidency. First shown in
Paris at the 1878 Exposition Universelle, *Elijah in the Wilderness* was
one of the last in a series of male nudes. There was much interest in
this Old Testament prophet in the Victorian era, perhaps resulting
from Mendelssohn's oratorio about him, performed in England for
the first time in 1846. In 1863 Leighton painted *Jezebel and Ahab...Met
by Elijah*. The subject was taken from *Kings I* in which Elijah escaped
from the vengeful Jezebel into the desert of Judah after successfully
revealing the power of God on Mount Carmel. Elijah was exhausted
by fasting and working. The figure has an anguished corporeal
dynamic: according to Leighton's biographer, Emily Barrington, he
had put much more energy into this than any other painting, as he
felt that biblical themes required a dramatic and forthright approach.
Elijah's abandoned pose is directly quoted from the *Barberini Faun*,
which Leighton would have seen in Munich as a youth. He has a
Baroque robustness and a musculature which recall Caravaggio, and
are in contrast to the upright stance of the spiritual, serene angel.
The composition is drowned in hues of rose and gold that capture the
heat and drought of the sun-baked landscape. The overtly religious
theatricality in Leighton's work of this period was not suited to the
sensibilities of English taste of the time, as the *Athenaeum* expounded:

> We suppose they may be taken as cosmopolitan; they are the
> work of a consummate master; they compel our admiration, but
> they do not sway our hearts, as they would if the artist designed
> to look down on this poor, workaday England of ours.

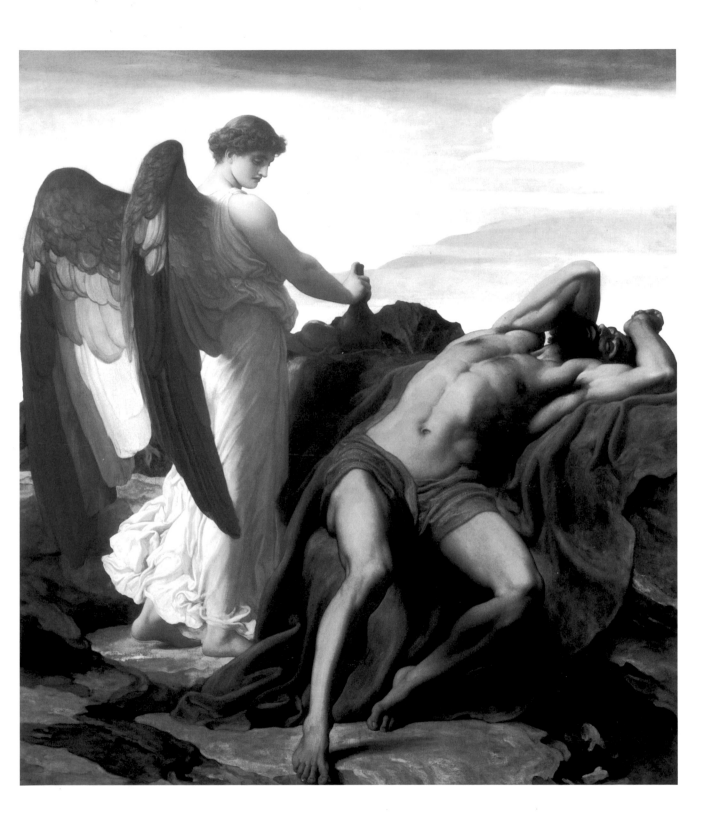

PLATE 22

BIONDINA

c.1879

Oil on canvas, 20 1/2 × 16 1/4 in / 52.1 × 41.3 cm

Hamburg Kunsthalle

Biondina was exhibited at the Royal Academy in 1879 and was bought by Gustave Christian Schwabe who donated it to the Hamburg Kunsthalle in 1886. It was one of a series of half- and three-quarter length paintings, usually executed on a small scale, of young female models dressed in peasant costume. Though naturalistic and painted from life, these paintings have a certain idealized soft-lens effect, particularly in the rendering of the heads. *Biondina*, whose treatment recalls the icons of Venetian masters such as Titian and can be likened to some of Rossetti's contemporary paintings, is innocent without being petulant or coy. Somewhat lacking in charisma, the women in these works are always charming, graceful and ethereal, qualities enhanced by their poetic names.

LIGHT OF THE HAREM
——————— c.1880 ———————
Oil on canvas, 60 × 33 in / 152.4 × 83.8 cm
Private collection

Harking back to the Oriental subjects that Leighton painted after his visit to Damascus in which the child model Connie Gilchrist appeared, *Light of the Harem* is one of his first works featuring Dorothy Dene, the favourite model he was to 'discover' in the last years of his life. She was to pose for him in some of his most memorable works, often in genre subjects of avowed sentimentality, in Oriental and classical costumes and later nude. These works, and Leighton's obvious affection for the young would-be actress, resulted in rumours that their relationship was more than that of artist and model. Dorothy Dene, whose real name was Ada Alice Pullan, also posed for other artists, including Leighton's friend G. F. Watts. He was especially attracted by her complexion which was described as '…a clouded pallor, with a hint somewhere of a lovely shell-like pink'.

PLATE 24

IDYLL
——————— c.1880–81 ———————
Oil on canvas, 41 × 83 1/2 in / 104.1 × 212.1 cm
Mr and Mrs Henry Keswick

Leighton has depicted a shepherd, seen from the back, playing pipes
to an audience of two resting dryads (forest nymphs). The entwined
pose of the two female figures recalls the reclining figures on the
Parthenon frieze; one supports herself on her elbow while her
companion rests upon her breast. They lie beneath a wide-spreading
oak on a sloping bank of grass scattered with autumn leaves. The
pastoral setting and the subtle evocation of mood are reminiscent of
George Mason's *Pastoral Symphony*. The title of the painting refers
generally to the *Idylls* of Theocritus. The dryads have been bewitched
by the shepherd's music. He plays to his animals, unaware of his
languid audience who will disappear when night falls and the music
ends. The tanned, robust, corporeal shepherd, outlined by the sea,
contrasts strongly with the rather ethereal nymphs. This, as well as
the colour scheme, closely links this painting to *Cymon and Iphigenia*.
The nymph on the right was reputedly modelled by Lily Langtry, the
mistress of the Prince of Wales.

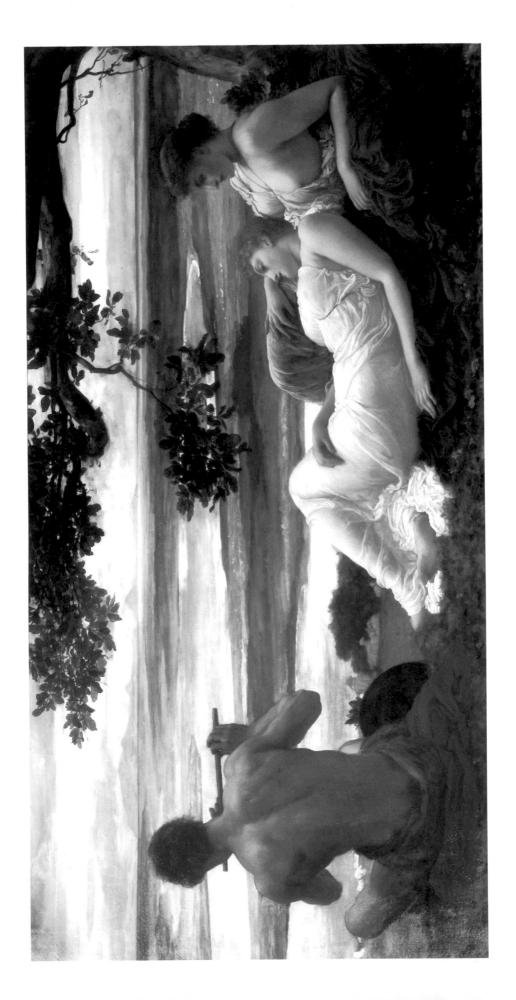

W E D D E D

———————— c.1881–82 ————————

Oil on canvas, 57¼ × 32 in / 145.4 × 81.3 cm
Art Gallery of New South Wales, Sydney

One of Leighton's most popular paintings, *Wedded* was one of the
first of his paintings to be reproduced as a print, as a result of which
it became widely known. In 1882 the original was purchased for
£1,500 and sent to Australia. It was acclaimed by Browning, who
remarked: 'I find a poetry in that man's work that I can find in no
other.' The composition and the subtlety of line and composition was
inspired by a variety of sources, including a sketch of a Greek girl
who had fascinated Leighton during his visit to Damascus, and a land-
scape painted on an earlier journey to the Alps. The subject however,
is Italian. The dignity of the figures is accentuated by their brilliant
drapery. The girl, in a contrapposto pose, is supported by the male
figure who is interchangeable with Leighton's *Cymon* – both are
strong men before female beauty.

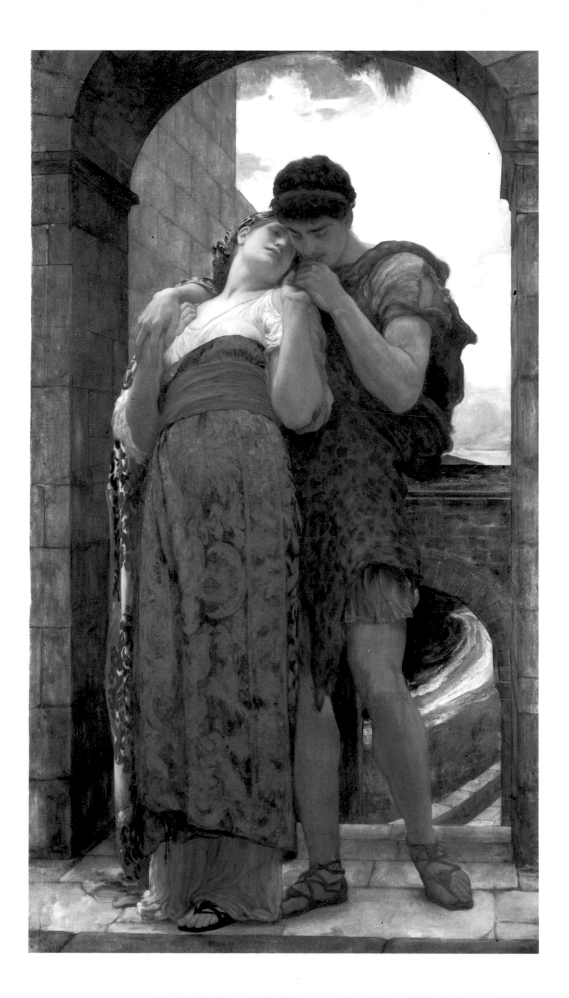

M E M O R I E S
———— c.1883 ————
Oil on canvas, 30 × 25 in / 76.0 × 64.5 cm
Private collection

Like *Biondina*, *Memories* belongs to Leighton's series of paintings of professional models to which he appended avowedly sentimental titles such as *Sister's Kiss*, *The Maid with the Yellow Hair* and *Wide, Wondering Eyes*, or girls' first names such as *Serafina*, *Amarilla* and *Catarina*. Like them, this painting has a soft-focus quality that sets it apart from Leighton's more characteristic classical work and appears to be by a quite different hand. The sitter for *Memories* was Edith Ellen Pullan, one of the four sisters of his beloved Dorothy Dene. Leighton often visited the Pullan family, and employed Dorothy's sisters as models.

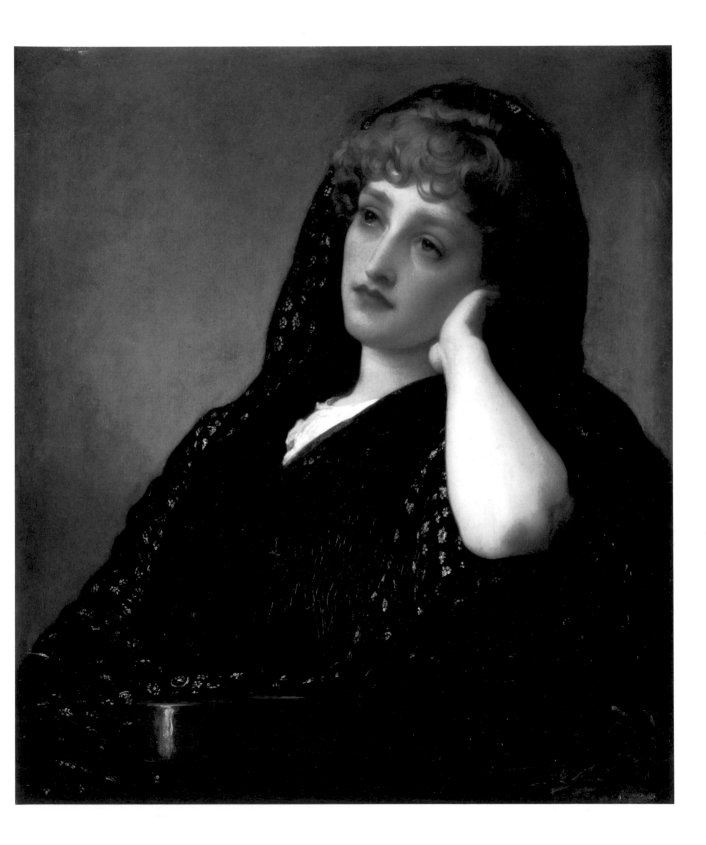

PLATE 27

CYMON AND IPHIGENIA
———————— c.1884 ————————
Oil on canvas, 64 × 129 in / 162.5 × 327.6 cm
Art Gallery of New South Wales, Sydney

Iphigenia was the daughter of Agamemnon who offered her to Artemis as a sacrifice to appease the goddess's wrath. Artemis felt compassion for the innocent victim and snatched her away at the moment of sacrifice, taking her to Tauris where she became a priestess of Artemis's cult. Victorian spectators may have found the title of this painting confusing, as it associates Iphigenia from Greek mythology with the relatively unknown Cymon, the son of Miltiades. The title is also that of a poem by Dryden:

> And on the margin of the fount was laid,
> Attended by her slaves, a sleeping maid.
> The fool of nature stood with stupid eyes,
> And gaping mouth that testified surprise,
> Fixed on her face, nor could remove his sight,
> New as he was to love, and novice in delight.

Leighton's haunting depiction of Iphigenia is taken from Boccaccio's *The Decameron* in which Cymon, a shepherd, discovers the sleeping figures of Iphigenia and her attendants, here placed in a visionary seascape. Momentarily captivated by admiration and beauty, he reflects upon his own simple existence. Boccaccio wrote: 'From a labourer, Cymon became a judge of beauty.' Boccaccio's version is set in spring, Leighton's in late summer, an ideal setting for languor and the treatment of the themes of immortal beauty and repose. The transient, surreal lighting of dusk, described by Leighton as '...the most mysteriously beautiful in the whole twenty-four hours,' comprising both sunlight and moonlight, surrounds the scene in an eerie half-light with only Iphigenia's draped form, in an abandoned pose, cocooned by the remaining luminous glow. Leighton described the moment: '...the merest tip of the moon has risen from behind the sea horizon, and the air is haunted still with the flush of the afterglow from the sun already hidden in the west.' The rectangular, vertical composition of this painting, which was bought by Sir W. E. Cuthbert Quilter, emphasizes the diagonal line of the recumbent figures.

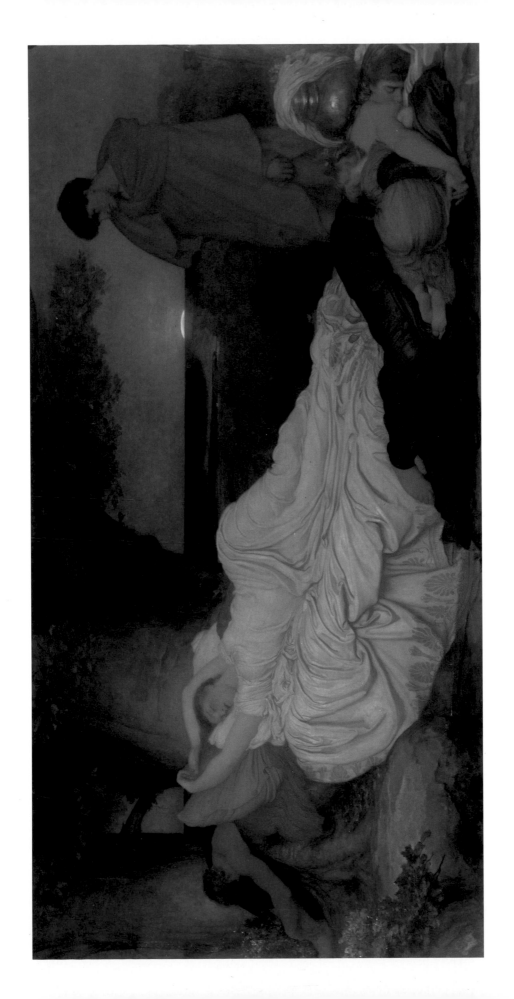

PLATE 28

CAPTIVE ANDROMACHE
———— c.1888 ————
Oil on canvas, 77½ × 160 in / 197.0 × 406.5 cm
Manchester City Art Galleries

Having planned this painting for several years and executed many preparatory studies, Leighton illustrated a subject which was suggested but not actually described in Homer's *Iliad*: Hector's prophecy about his wife as a lonely captive after the fall of Troy. *Captive Andromache* is a culmination of Leighton's series of processional paintings. It depicts the imprisoned Andromache, one of the most noble characters in the *Iliad*, amongst the women of Epirus. The scene is set in a farmyard of Pyrrhus in Thessaly. The slight narrative may not really justify the huge scale of the painting, but Leighton used the theme as a pretext for representing alienation, the mood indicated by the main figure's sombre drapery and solitary form. Exhibited at the Royal Academy in 1888, the picture was accompanied by lines from Elizabeth Barrett Browning's translation of the *Iliad*:

> Some standing by,
> Marking thy tears fall, shall say 'This is she,
> The wife of that same Hector that fought best
> Of all the Trojans when all fought for Troy.'

Andromache was modelled by Dorothy Dene. Her configuration could be interchanged with that in Leighton's *Day Dreams* and his *Helen of Troy*. Lena Dene, Dorothy's younger sister, posed for the young woman on the left accompanied by children. The pose of the sleeping figure can be seen later in *Flaming June*. Writing in the *Athenaeum*, F. G. Stephens likened the painting to Greek bas-relief. Typically, Leighton designed his own frame, echoing the architectonic elements in the painting. Here it is an integral part of the aesthetic effect of the large-scale piece. *Captive Andromache* was generally well received, the *Magazine of Art* celebrating it as the masterpiece of Leighton's career:

> It has been thoroughly well thought out, and is not only an admirable example of the excellences and faults of its painter...but is in itself a complete exposition of the art of painting...subject, composition, line, character, colour – are all here.

The advent of provincial galleries provided an invaluable new source of patronage for Leighton and his contemporaries. *Captive Andromache* was bought by Manchester City Art Gallery for £6,000 – the record price paid for one of Leighton's paintings during his lifetime – which was raised by subscription. However, the gallery was reluctant to loan the painting when Leighton requested it, at very short notice, as a British contribution to the 1889 Paris Exhibition with which the artist was closely involved.

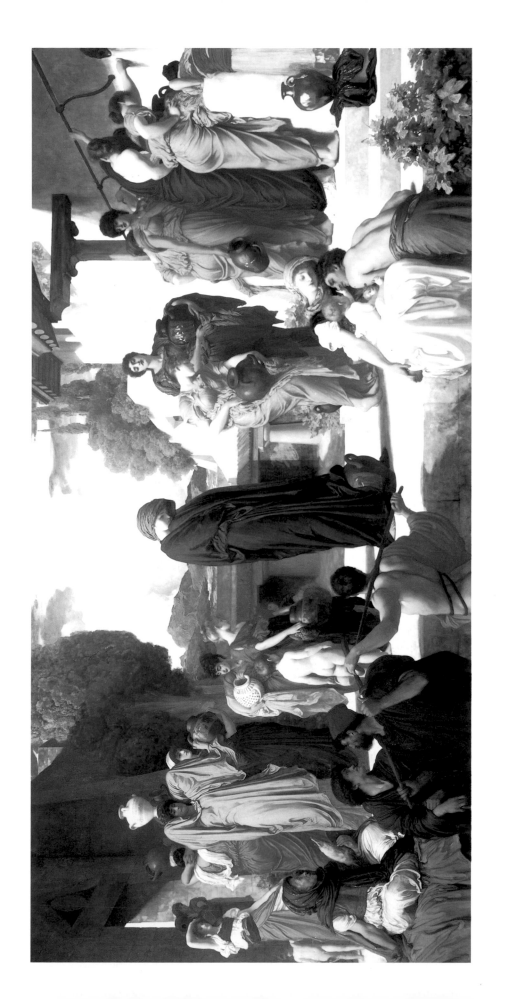

PLATE 29

GREEK GIRLS PLAYING AT BALL
———————————— c.1889 ————————————

Oil on canvas, 47 × 78 in / 119.4 × 198.1 cm
Dick Institute, Kilmarnock

This was one of Leighton's last paintings in which he attempted to represent the dynamics of movement. He did this by means of the draperies mirroring the actions of the figures and so forming momentary shapes. Leighton may have been influenced by the theories Ruskin expounded in *The Seven Lamps of Architecture*, in which he stated that drapery was only noble and necessary if it expressed motion or gravity. Pictorially this painting recalls Titian's *Rape of Europe*, in which patterns are formed by draperies before a panorama. Leighton had made notes on the subject himself: 'Combination of expressed motion and rest source of fascination in drapery — wayward flow & ripple like a living water together with absolute repose.' In preliminary studies the composition appeared more compressed, with the figures much closer together. As the picture progressed, the girls, reminiscent of works by Michelangelo, drifted apart and one of Leighton's best Mediterranean seascapes was inserted.

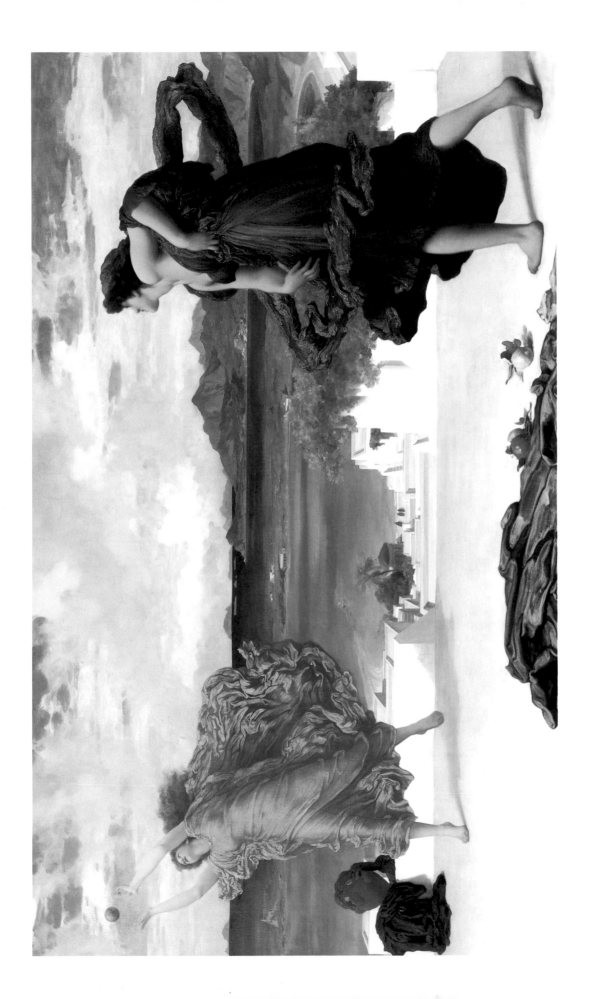

The Bath of Psyche
———————— c.1890 ————————
Oil on canvas, 74 1/2 × 24 1/2 in / 189.2 × 62.2 cm
Tate Gallery, London

Psyche, meaning soul in Greek, was a beautiful mythological princess who suffered many traumatic ordeals. Ordered by an oracle to sacrifice her, Psyche's father left her on the summit of a mountain to be devoured by a monster. She was rescued by Zephyrus and taken to a magnificent palace where the man who was destined to be her husband, Eros, would appear to her in the darkness of night. Eros instructed Psyche not to attempt to look at his face, but when she was encouraged to look at him by her envious sisters, she burnt him by accident with lamp oil. On waking, Eros reproached Psyche and vanished, as did the palace. Once again Psyche found herself alone on the rock. Through mysterious divine intervention, she survived a suicide attempt and the jealous Aphrodite's continuing harassment. Finally, Eros implored Zeus to reunite them and make his lover immortal, and they were then married on Mount Olympus.

Leighton depicts the moment where Psyche prepares to bathe for her wedding. Based on his sketches of women undressing for Phryne, this serene depiction of the female form recalls the *Callipygian Venus*, in which a young women exposes her legs and buttocks. Psyche's sensuous corporeality and diaphanous drapery are set against and enhanced by the classical architectural features, her legs reflected in the pool by which she stands. The verticality of the composition, of which she is a formal component, makes her figure appear all the more slender. Here the vulnerable Psyche is exposed for the benefit of the anonymous voyeur, as in the myth where she was offered to an unknown husband. Leighton's contemporaries greatly admired this sensual painting. J. Harlaw, author of *The Charm of Leighton*, describing its eroticism:

> Psyche's contour is perfect and her form is deliciously rounded. The exquisite pearly fairness of the skin must ever make this rendering of the amorous deity the standard of as modelling...Dorothy Dene, Leighton's favourite model, here displays her charms for the admiration of mankind.

Though titillating, the mythological theme and its classical rendering justified the acceptability of the painting, although nudes by contemporary artists such as Alma-Tadema and Poynter were sometimes labelled as salacious. Leighton saw the nude as the pinnacle of classical beauty. The figure bears a close resemblance to that in the ceiling painting of 1888 by Gustav Klimt on the staircase of the Burgtheater, Vienna. A common source, rather than a direct quotation of the Viennese artist, is the most likely explanation for this. Many studies were made for this painting, which was sold to Henry Tate for £1,000 as part of the Chantrey Bequest.

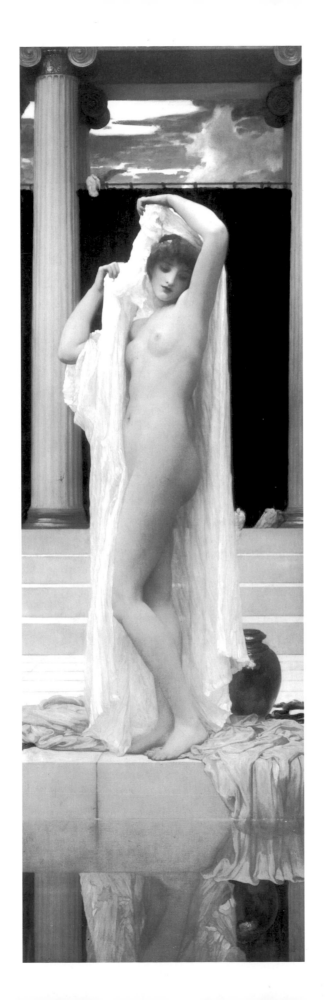

'AND THE SEA GAVE UP THE DEAD
WHICH WERE IN IT'
———————————— 1891–92 ————————————
Oil on canvas, 90 in / 228.6 cm diameter
Tate Gallery, London

Commissioned by Henry Tate for his forthcoming gallery of British painting, this is one of Leighton's few biblical subjects on an apocalyptic theme. Depicting a vision of the resurrection of souls on Judgement Day, the subject was taken from the *Book of Revelations*. The first design for the composition was made in the early 1880s as one of eight roundels designed for a scheme of mosaics on the apocalypse for the dome of St Paul's Cathedral. The design was rejected by the Dean of the Cathedral as a result of its supposed unchristian treatment of the subject, and the scheme was abandoned in 1885. Leighton believed this to be his best design to date and worthy of a place in a national collection: '…now this is the work I should wish to be remembered by in our National Gallery', and thus he utilized it to create this painting. Samuel Pepys Cockerell praised the composition and its execution:

> This great group is one which no other painter in this country could have attempted with any chance of success. It shows astonishing mastery, and is worthy to rank with the finest work in the Sixtine [sic] Chapel.

The main group of figures consists of an overwhelmed man supporting his wife and child as they emerge tentatively from the sea and back to life. The colour scheme defines each figure's state of consciousness: the live man is reddening, his unconscious wife has a deathly pallor and their comatose son is merely pale.

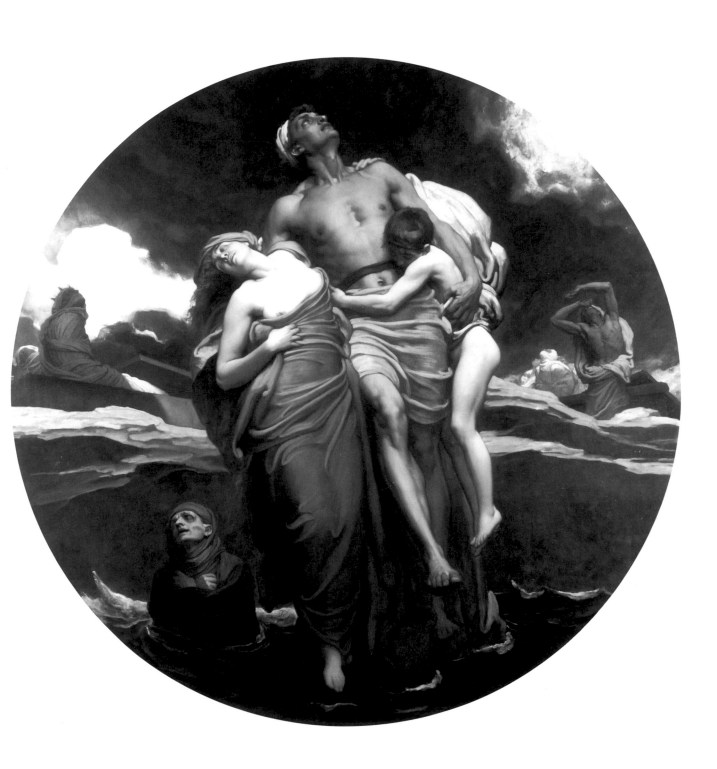

PERSEUS AND ANDROMEDA
———————— c.1891 ————————

Oil on canvas, 92 ¹/₂ × 51 in / 235.0 × 129.3 cm
Board of the Trustees of the National Museums and Galleries on Merseyside
(Walker Art Gallery, Liverpool)

Taken from Ovid's *Metamorphoses*, this painting is a narrative sequel
to Leighton's *Perseus and Pegasus*, although it is the earlier work. This
is a very original treatment of this popular classical theme.
Andromeda, daughter of Cepheus, was offered to a sea monster sent
by Poseidon to avenge Cepheus's wife Cassiopeia's claim that she was
more beautiful than the Nereids. Cepheus consulted the Oracle of
Ammon and was told that he must sacrifice his daughter. Perseus
arrived to find Andromeda bound to a rock, and fell in love with
her. He killed the monster, liberated Andromeda and then married
her. Here Andromeda, nude except for drapery around her waist, is
bound to the rock. The monster looms above with outstretched scaly
wings forming a canopy over his captive. Perseus appears from the
clouds on Pegasus, firing arrows. The scene is set in an eerie rocky
inlet in a coastline in which vertical cliffs ascend from an inky sea.
The landscape is based on sketches made on the Donegal coast of
Ireland at Malin Head. Leighton described the setting as '…quite
Dantesque in its grim blackness'. The colouring evokes spiritual
forces and symbolically distinguishes the nature of the characters, the
radiant hero, the life-saving source of light, glowing gold and white,
the victim dressed in white, contrasted by the oily green dragon. The
dragon was based on studies of prehistoric creatures and Andromeda
was modelled by Dorothy Dene. The rather incongruous group of the
mounted Perseus on Pegasus was drawn from a model made by
Leighton, plagiarizing a print by the Dutch artist Hendrik Goltzius.
The action draws the spectator into the distant horizon of the sea. The
painting was retouched prior to being exhibited at Oldham in 1894.

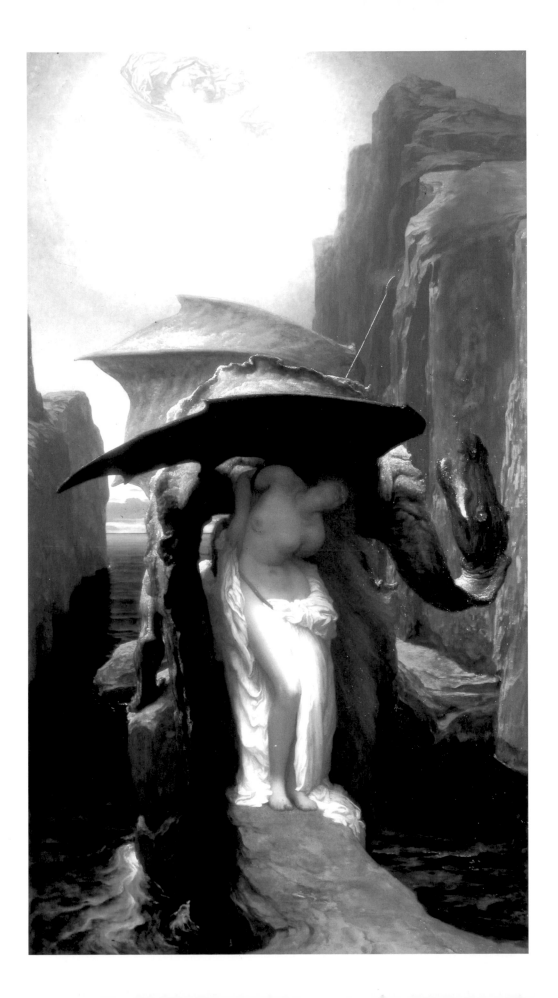

PLATE 33

RETURN OF PERSEPHONE
———————— c.1891 ————————

Oil on canvas, 80 × 60 in / 203.2 × 152.4 cm
Leeds Museums and Galleries

Like *Perseus and Andromeda*, derived from Ovid's *Metamorphoses*, this painting depicts a widely-represented mythological figure. Persephone was the goddess of the Underworld and wife of Hades; her name can be translated as 'she who destroys light'. Before her marriage to Hades, Persephone lived on earth with her mother Demeter, who conceived her by Zeus, and was known as Kore. She was abducted by Hades whilst picking flowers and carried into the Underworld on his chariot. Demeter failed to recover her daughter but accepted the Gods' compromise of Persephone spending part of the year with her on earth. Persephone's iconographic attributes are the bat, the narcissus and the pomegranate. Her cult merged with that of her mother's which had similar rites. This work was shown with *Perseus and Andromeda* at the Summer Exhibition of 1891. In it Leighton depicted Persephone's limp body in shroud-like drapery, being carried towards her mother by Hermes, the messenger of the Gods. Demeter in warm-toned drapery with tanned outstretched arms prepares to embrace her child. The reunion takes place at the mouth of a cave leading to the Underworld, through which we see the bright daylight. The two worlds on either side are symbolized by flora, the sprays of cherry blossom outside contrasting with the darkly menacing non-flowering plants on the inside of the cave. Outside the landscape blooms, Persephone having regained the sunlight. Persephone's upreaching configuration symbolizes the principle of growth, bursting towards the light, while Demeter represents earthly fertility. The mother and child relationship was a recurrent theme in Leighton's work, associated here with summer and winter, light and darkness, and life and death. The painting was purchased by Sir James Kitson for presentation to Leeds City Art Gallery.

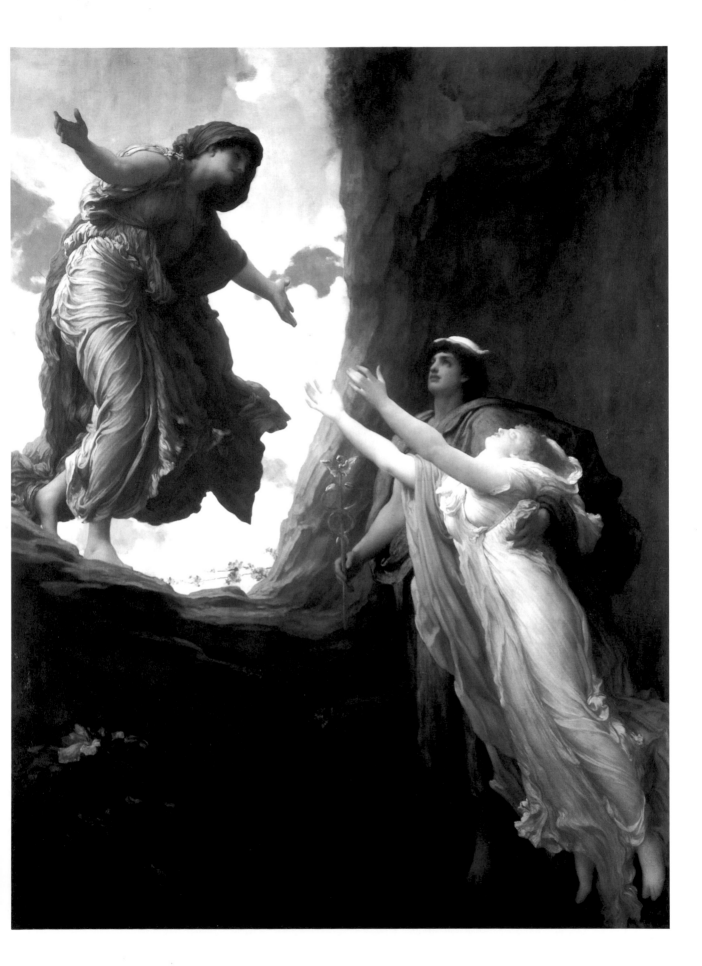

PLATE 34

The Garden of the Hesperides
———————————— c.1892 ————————————
Oil on canvas, 66 ½ in / 169.0 cm diameter
Board of the Trustees of the National Museums and Galleries on Merseyside
(Lady Lever Art Gallery, Merseyside)

The Hesperides were the daughters of Hesperus who had the power of everlasting song. They lived at the extreme western limits of the world in a wonderful garden, and protected the golden apples that grew there. Myth suggests that the daughters of Hesperus sang a lullaby to the guardian of the golden apples, the dragon Ladon who was appointed by Juno. Here the dragon, in the form of a serpent recalling the imagery of the Garden of Eden, coils itself around the three young women and the apple tree, with golden fruits hanging from heavy branches above them. The three languid, auburn-haired girls, one of whom was modelled by Dorothy Dene, are draped in richly coloured robes. The central figure is an idealized beauty with a foreshortened body and classical facial features. The somnolent figures are framed by water, the sea behind and by the pool in front, and are surrounded by lush vegetation. This was echoed in Leighton's own picture frame with a circular moulding of foliage and fruit. The tondo composition encloses them in their suspended, cyclical world. The theme of death-in-life relates the painting to Tennyson's poetry, particularly his poem 'The Hesperides'. Other likely sources of inspiration for the theme were Milton's poem 'Comus', Flaubert's erotic and decadent novel *Salammbô* and Ruskin's investigation of the theme in his consideration of Turner's work in *Modern Painters*.

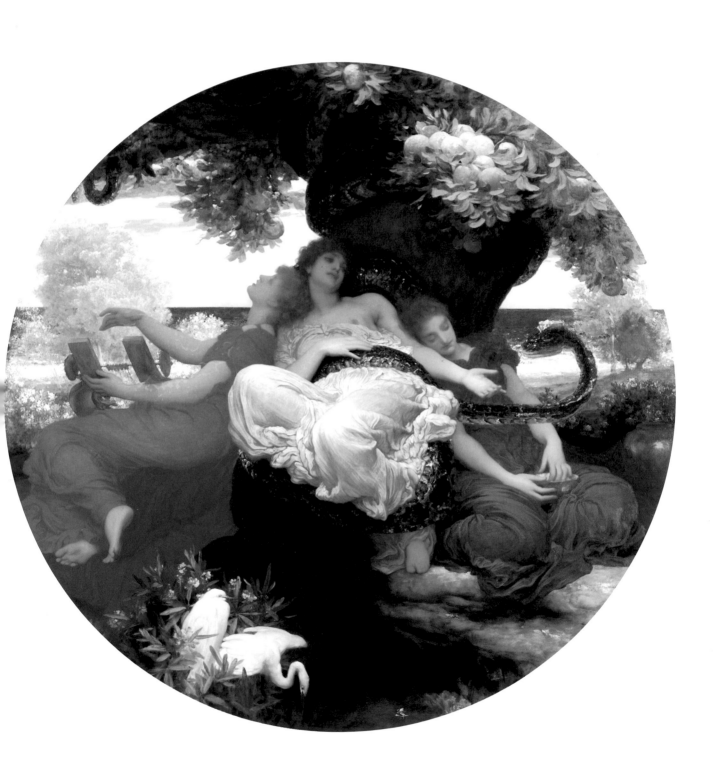

PLATE 35

AT THE FOUNTAIN
——————— c.1892 ———————
Oil on canvas, 50¼ × 37½ in / 127.6 × 95.3 cm
Layton Art Collection, Milwaukee Art Museum, Gift of Friends of the Layton
Art Gallery

At the Fountain was purchased in 1895 for the Layton Art Gallery.
The half-length, single female figure, holding a large water jar under
her right arm, is silhouetted against the illuminated marble colonnade
behind her. Touches of subtle colour are provided by her fair hair,
pale drapery and the lemons hanging from a branch. The painting was
purchased in 1895 by the Layton Art Gallery, one of relatively few
subjects that were acquired by American collections during
Leighton's lifetime. A small colour sketch of the work remains in
England, in the Fulham Library.

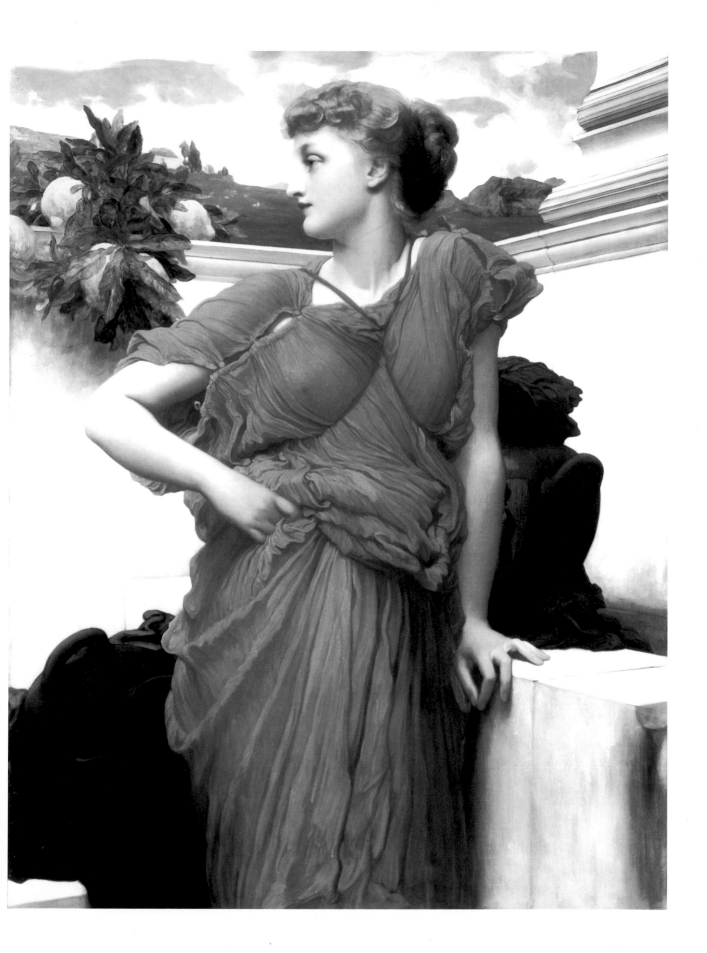

FATICIDA
c.1894

Oil on canvas, 60 × 43 in / 152.5 × 109.0 cm
Board of the Trustees of the National Museums and Galleries on Merseyside
(Lady Lever Art Gallery)

Faticida was a prophetess who foretold the future to women. The green-white drapery matches her calm mood, evoked by her relaxed posture and enigmatic facial expression. There is a thick, expressive handling of paint seen in the treatment of the opaque drapery. Faticida leans back with crossed legs, with her head in her left hand, a pose derived from Michelangelo's seated sibyls in the Sistine Chapel. Enclosed in an alcove of purplish stone, Faticida is the most monumental of Leighton's sibyl-type figures. Brighter colour is provided by laurel leaves at her feet, heightened by light reflected in her metal tripod and the gilded ceiling. The painting was exhibited at the Royal Academy in 1894 and acquired by Lord Leverhulme.

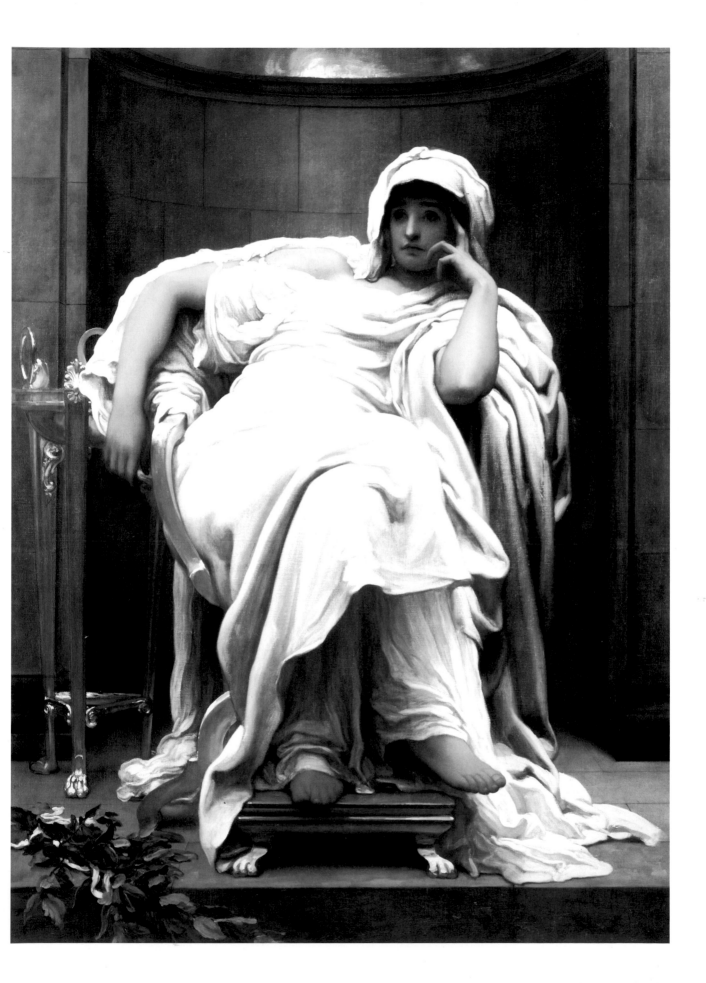

THE SPIRIT OF THE SUMMIT

—— c.1894 ——

Oil on canvas, 78 × 40 in / 198.1 × 101.6 cm
Auckland City Art Gallery; collection presented by Mr Moss Davis, 1924

This painting was shown at the Royal Academy Summer Exhibition with four other female personifications, ranging from this symbolic work and *Faticida* to a domestic scene in *The Bracelet*. *The Spirit of the Summit* is a representation of the purity of the human spirit. It attests to Leighton's commitment to the truths of art and beauty, and to his aspirations to high ideals. The chaste, fair figure sits regally at the snowy peak of a mountain, gazing towards a starry sky that illuminates her white robes. The background was based on studies made by Leighton in Zermatt in the autumn of 1893. The painting was anticipated by Moritz von Schwind's *Jungfrau*, and follows the German pantheist tradition of interpreting the forces of nature and art. Less monumental than Schwind's personification, this figure conforms to a classical prototype. In the theatrical lighting, she can be likened to a character in a Wagner opera, although the figure was painted from life. The model was the expressive actress Dorothy Dene.

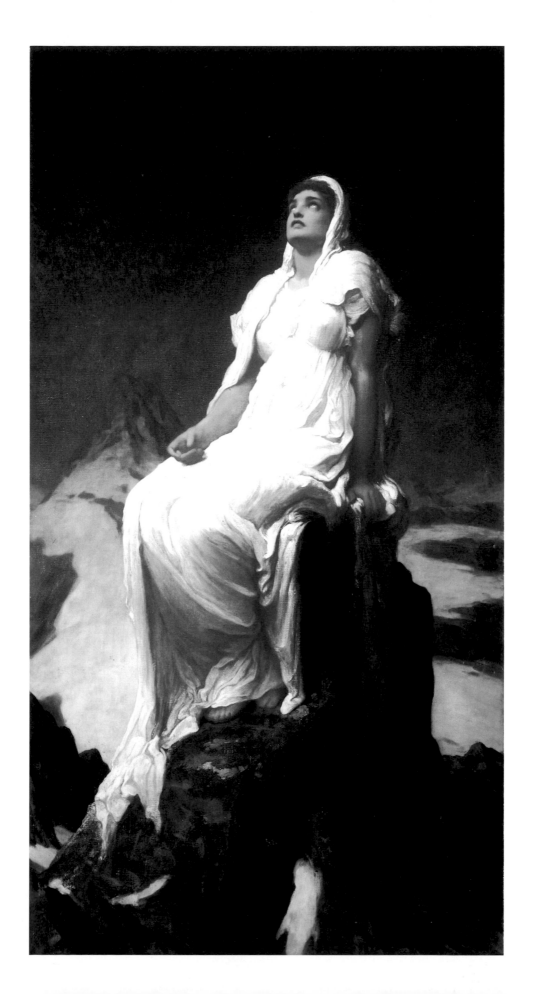

FLAMING JUNE

c.1895

Oil on canvas, 47¹/₂ × 47¹/₂ in / 120.6 × 120.6 cm

Museo de Arte de Ponce (The Louis A. Ferré Foundation), Puerto Rico

One of Leighton's best known and most widely reproduced works, *Flaming June* is an exploration in colour and form. Leighton's most abandoned tribute to beauty had been anticipated two decades earlier in the reclining figure in *Summer Moon*, as well as in *Captive Andromache* and is also a possible sequel to his *Summer Slumber* of 1894. Another possible and more contemporary source was *Hope* by G. F. Watts which had been exhibited at the Grosvenor Gallery in 1886. According to Leighton, however, the monumental form, which recalls Michelangelo's *Night* in the Medici Chapel in Florence, was not intentionally arranged but occurred naturally when the fatigued model was resting. The condensed composition was the result of many frenzied preparatory studies. There is no apparent subject matter; this is simply a depiction of a young woman sleeping in brilliant sunlight. Through the unifying curtain of luminous glow, we glimpse the sea with the sun's reflection on it. However all extraneous detail was reduced so that the spectator would concentrate on the confined figure, modelled by Dorothy Dene. Despite the claustrophobic setting, the figure has a certain passivity in the luxuriant ambience. Vibrant orange diaphanous drapery emerges like flames, erupting over the woman's figure and illuminating parts of her face, neck, forearms and foot. Leighton's statements in his Academy notebooks anticipated the execution of *Flaming June*:

> A deep slow cumulative execution...is suitable only for subjects of repose...all the qualities of a work of art must be struck in the key and appeal to the order of sensation...suffusion of colour (saturation) gives idea of an overmastering impulse.

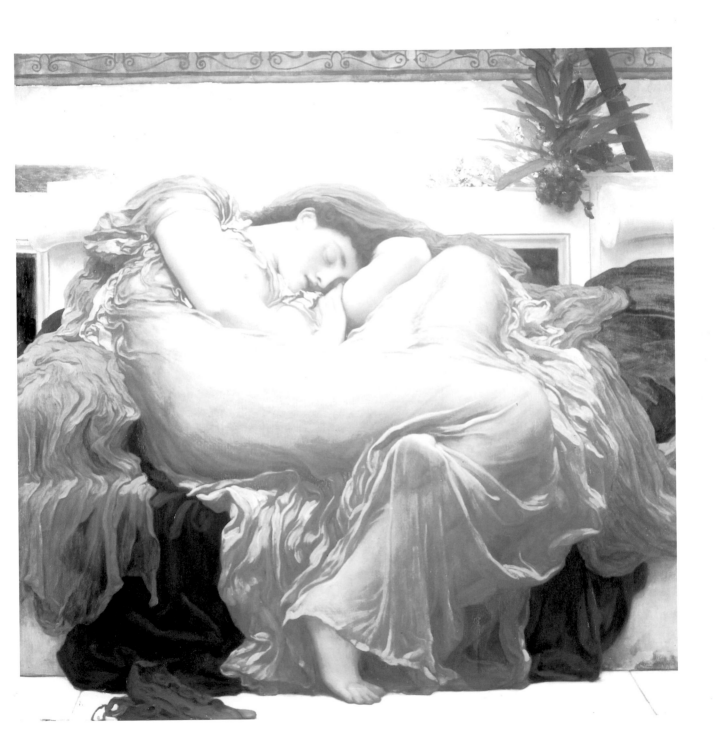

PLATE 39

LACHRYMAE
—————— c.1895 ——————

Oil on canvas, 62 × 24¾ in / 157.5 × 62.9 cm
The Metropolitan Museum of Art, New York, Catharine Lorillard Wolfe
Collection, Wolfe Fund, 1896. (1896.28)

Taken from a watercolour executed in Florence in 1854, *Lachrymae* has no specific mythological or historical reference. Set in the early evening, with a harsh sunset and solemn cypress trees in the background, the mourning figure has been depicted to convey a sense of loss and the theme of grief. The tragic ambience is evoked by Leighton's use of sombre colour and the verticality of the composition. The grieving woman, draped in black, rests on a truncated Doric column upon which stands a funerary urn, her height accentuated by the rising trunk of the yew tree behind. The flickering light emanating from behind the tree suggests a funeral pyre. The verticality of the composition, used in neo-Gothic architecture, in line with Pugin's and Ruskin's theories of design, is symbolic of resurrection and closeness to God. It refers to the ascending spirit of her deceased lover, whom she is unable to follow. The low wall forms a symbolic cross with the column, a compositional device that was frequently used by the Pre-Raphaelites decades earlier and represents the end of continuity and happiness in a phase of life. The configuration of the woman recalls the classical statue of Melpomene in the British Museum, in which a draped figure leans on a plinth.

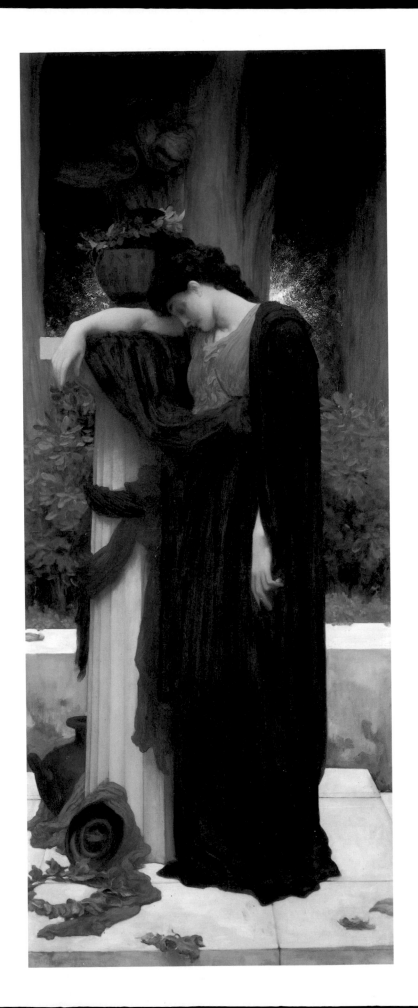

PLATE 40

PERSEUS ON PEGASUS HASTENING TO
THE RESCUE OF ANDROMEDA

──────────── c.1895–96 ────────────

Oil on canvas, 72 1/2 in / 184.2 cm diameter
Leicestershire Museums, Arts and Records Service

Ovid's *Metamorphoses* tells how Polydectes wanted to impress
Hippodaemia with various wedding gifts. Much to the relief of jeal-
ous Polydectes, the warrior Perseus, his vassal, was anxious for
distinction and offered to obtain Medusa's head. The warrior decapi-
tated Medusa with one stroke of his sickle and the winged horse
Pegasus sprang from her bloody neck. Perseus then fled on the back
of Pegasus carrying Medusa's head. This painting, unfinished when
found in the artist's studio on his death, features a theme tackled
earlier in his *Perseus and Andromeda* of 1891. Here Leighton used the
same bronze model of the figure mounted on horseback, but slightly
turned and at closer range. Unlike the first painting which has more
dynamism and perspective, the action is classically balanced in the
confines of a narrow picture plane.

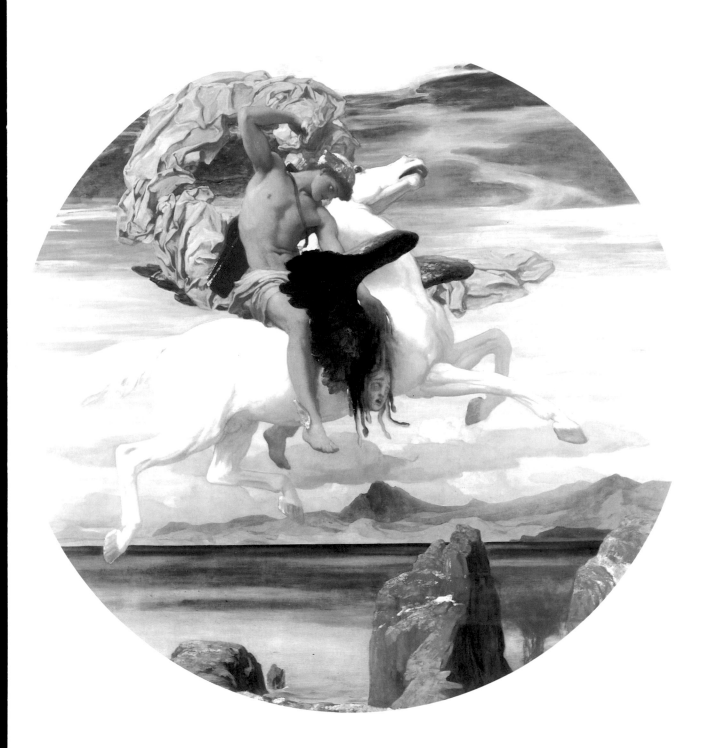

SELECT BIBLIOGRAPHY

Emily (Mrs Russell) Barrington, *Life, Letters and Work of Frederic Leighton*
London: George Allen, 1906

Wyke Bayliss, *Five Great Painters of the Victorian Era*
London: Sampson Low, 1902

William Gaunt, *Victorian Olympus*
London: Jonathan Cape, 1952

Christopher Newall, *The Art of Lord Leighton*
Oxford: Phaidon Press, 1990

Leonée and Richard Ormond, *Lord Leighton*
New Haven and London: Yale University Press, 1975

Richard Ormond, *Lord Leighton's Frescoes in the Victoria and Albert Museum*
London: Victoria and Albert Museum, 1975

Ernest Rhys, *Frederic Lord Leighton*
London: George Bell & Sons, 1898

Royal Academy, *Exhibition of Works by the Late Lord Leighton of Stretton, PRA*
London: Royal Academy, 1897

Frederick George Stephens, *Artists at Home*
London: Sampson Low, 1884

PRINCIPAL PUBLIC COLLECTIONS CONTAINING
WORKS BY LEIGHTON

AUSTRALIA

Adelaide
Art Gallery of South Australia

Armidale
Teacher's College

Sydney
Art Gallery of New South Wales

CANADA

Ottawa
National Gallery of Canada

GERMANY

Hamburg
Hamburg Kunsthalle

Frankfurt
Städelsches Kunstinstitut

GREAT BRITAIN

Aberdeen
Aberdeen Art Gallery

Bath
Victoria Art Gallery

Birmingham
Birmingham City Art Gallery

Blackburn
Blackburn Museum and Art Gallery

Bournemouth
Russell-Cotes Art Gallery and Museum

Bristol
Bristol Art Gallery

Cambridge
Fitzwilliam Museum

Faringdon
Buscot Park

Grantham
Belton House (National Trust)

Hull
Ferens Art Gallery

Kilmarnock
Dick Institute

Leeds
Leeds Museum

Leicester
Leicester Museum and Art Gallery

Liverpool
Sudley House
Walker Art Gallery

Lode
Anglesey Abbey (National Trust)

London
Fulham Library
Guildhall Art Gallery
Leighton House
William Morris Art Gallery, Walthamstow
National Portrait Gallery
Royal Exchange
South London Art Gallery
Tate Gallery
Victoria and Albert Museum

Lyndhurst
St Michael's Church

Manchester
Manchester City Art Gallery

Oxford
Ashmolean Museum

Port Sunlight
Lady Lever Art Gallery

Scarborough
Scarborough Art Gallery

Stourton
Stourhead (National Trust)

Truro
Royal Institution of Cornwall

INDIA

Baroda
Baroda Museum and Picture Gallery

Hyderabad
Salar Jung Museum

IRELAND

Dublin
Municipal Gallery of Modern Art

ITALY

Florence
Uffizi Gallery

NEW ZEALAND

Auckland
Auckland City Art Gallery

Christchurch
Robert McDougall Art Gallery

PUERTO RICO

Ponce
Museo de Arte de Ponce

UNITED STATES OF AMERICA

Boston, Massachusetts
Museum of Fine Arts

Decatur, Georgia
Agnes Scott College

Hartford, Connecticut
Wadsworth Atheneum

Fort Worth, Texas
Kimbell Art Museum

Milwaukee, Wisconsin
Milwaukee Art Museum

Minneapolis, Minnesota
The Minneapolis Institute of Arts

New Haven, Connecticut
Yale Center for British Art

New York, New York
Metropolitan Museum of Art

Princeton, New Jersey
Princeton Art Musum

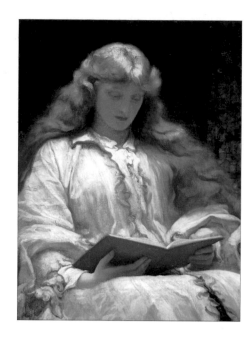

This edition first published in 1997 by
PAVILION BOOK LIMITED
London House, Great Eastern Wharf, Parkgate Road, London SW11 4NQ
First published in 1995 by PAVILION BOOKS LIMITED
Produced, edited and designed by Russell Ash and Bernard Higton
Text copyright © Russell Ash 1995

Designed by Bernard Higton
Editorial research by Vicki Rumball
Picture research by Mary-Jane Gibson

A CIP catalogue record for this book is available from the British Library.

This book is typeset in Monotype Perpetua

ISBN 1 86205 150 X

Printed and bound in Singapore by KYODO

2 4 6 8 10 9 7 5 3 1

This book may be ordered by post direct from the publisher.
Please contact the Marketing Department.
But try your bookshop first.

PICTURE CREDITS

Half-title: *Acme and Septimus* (c.1868), Ashmolean Museum, Oxford
Frontispiece: *The Countess Brownlow* (c. 1879), Belton House (National Trust)
Above: *The Maid with the Yellow Hair* (c.1895), Private collection, photo
Christie's/Bridgeman Art Library

4, 5r, 7, 11r, 12t, 12b National Portrait Gallery, London; 5l Leighton House; 6 Agnes
Scott College, Decatur, Georgia; 8 Tate Gallery, London; 9l Mansell Collection,
London; 9r Private collection, photo Sotheby's; 10 Private collection, photo Fine Art
Picture Library; 11l Board of the Trustees of the National Museums and Galleries on
Merseyside (Lady Lever Art Gallery), photo Bridgeman Art Library;
11b Victoria & Albert Museum.

All colour plates were supplied by and are reproduced with the permission of the
collections listed. Additional photo credits: Plate 2 Christopher Wood
Gallery/Bridgeman Art Library; Plates 5, 15 Sotheby's; Plate 16 Christie's;
Plate 19 Bridgeman Art Library; Plate 23 The Fine Art Society/Bridgeman Art Library;
Plate 26 Bridgeman Art Library.